IMAGES
of Modern America

THE WORLD OF
LITTLE LEAGUE®

IMAGES
of Modern America

THE WORLD OF LITTLE LEAGUE®

Janice L. Ogurcak
Foreword by Congressman Tom Marino

ARCADIA
PUBLISHING

Published by Arcadia Publishing
Charleston, South Carolina

Printed in the United States of America

Library of Congress Control Number: 2014957990

For all general information, please contact Arcadia Publishing:
Telephone 843-853-2070
Fax 843-853-0044
E-mail sales@arcadiapublishing.com
For customer service and orders:
Toll-Free 1-888-313-2665

Visit us on the Internet at www.arcadiapublishing.com

This book is dedicated to my husband, Richard,
who supports my ventures and adventures.

CONTENTS

FOREWORD

When Janice Ogurcak asked me to write a foreword for her book, I immediately said yes. It rates right up there with throwing out the ceremonial first pitch of the game, which I have done.

I remember my very first Little League Baseball World Series game: that was 57 years ago. Mexico defeated California. I tell anyone who will listen that Little League Baseball World Series is the best baseball that they will ever experience, especially in South Williamsport, Pennsylvania.

I played Little League Baseball, most of us did. I was a pitcher, a southpaw. If one reads this book, no explanation is required as to what that means. However, that was when bats were made of wood, there were no night games because the fields did not have lights, and there was no 10-run rule. All of that has changed. Nevertheless, I love the game even more.

Baseball is the quintessential all-inclusive human entertainment. The fans, on occasion, are known to get a bit enthusiastic, especially if one's team loses. Regardless, it is truly genuine Americana.

For those of you who have not seen a Little League Baseball World Series game, add it to your bucket list. In fact, put it at the top to enjoy with your family. Lamade Stadium is one of the most beautiful ballparks in the United States. The interactive museum will knock your socks off, guaranteed. The history, the artifacts, the photographs, the displays, and the list of players are some of the most extraordinary exhibits that one will view.

When I introduce myself as a congressman, I tell people that I am from "The home of the Little League Baseball World Series, and that I am very proud of it." The thrill of watching 11- and 12-year-old boys and girls from all over the world compete is breathtaking. Each player's ability to throw faster, hit farther, and execute flawless plays is, well, one has to see it to believe it.

Thank you, Janice; you knocked this one out of the park, my friend.

—Congressman Tom Marino

ACKNOWLEDGMENTS

My sincere thanks to the staff at the World of Little League®: Peter J. McGovern Museum and Official Store, particularly to Lance Van Auken, executive director; Adam P. Thompson, curator; and Adam Stellfox, who assisted with research.

This book would not have been possible without Robin Van Auken and everyone who gave me moral support, including Abby Walker, Lily Watkins, and Ryan Easterling, my editors. Much gratitude is given to the many people I interviewed and who shared photographs to complement what is in the museum's archives.

Unless otherwise noted, all images appear courtesy of the World of Little League® Museum Archives.

INTRODUCTION

A piece of the Berlin Wall, a dental articulator, a beanie, and miniature troll doll are on display with baseball and softball artifacts at the World of Little League Museum. Wondering why?

All of these items are part of the story of the development of Little League® Baseball and Softball into the largest organized youth sport in the world. Their historical relevance is shared throughout the museum, making it a fun and unique place to visit.

First opened in 1982, the World of Little League Museum reopened during the summer of 2013 after a $4.3 million renovation project that included removing every artifact and many of the structure's interior walls, in addition to refocusing on its mission about Little League Baseball and Softball.

Artifacts from the early days next to state-of-the-art interactive exhibits connect the past with the present. On the Global Connections Touch Table, powered by ACTIVE Network and similar to a huge iPad, visitors can play a trivia game, learn geography, look up a league in their neighborhood, or send a message to any local league worldwide. There are Little League Baseball World Series championship game highlights to watch, rarely seen film footage of founder Carl E. Stotz, audio from early players, and interactive games.

The museum takes the history of Little League and relates it to international events and activities. The stories intertwine with the history of the sport, organized in 1939, and share how world events helped shape Little League. More so, the World of Little League® is a place where people of any age will connect with several generations. For those who have been involved, currently playing, or are volunteering in a Little League, it is a magical journey. For someone new to Little League, it is a great experience.

The World of Little League Museum focuses on the overall picture of the youth sports organization—from its roots in a community, to its heritage, to its accomplishments, and to players who have gone on to make a difference in their town or even the world.

One

LITTLE LEAGUE®
OVERCOMES ADVERSITY

Overcoming adversity, abilities, and challenges, Little League Baseball and Softball continues to show off its finest—in a museum adjacent to the complex where the Little League Baseball World Series has been played for most of the program's 75 years.

In telling the story about the program that began in 1939 as the vision of founder Carl E. Stotz, the museum draws upon artifacts, photographs, films, personal testaments, and life experiences.

Little League has weathered many events and changes since it began, and yet it continues to adapt and provide a positive experience for all boys and girls.

Integration occurred in the second year of the program as Little League spread throughout the city of Williamsport and into neighboring communities, often identified by the nationality of the people living there. According to the rules, any boy was permitted to play. But that was challenged in the Deep South where segregation was the norm.

Initially begun as Baseball for Boys, the organization's federal charter was amended in 1974 to allow girls to play baseball and also to launch the Little League Softball program. Little League Baseball never asked its local leagues for figures on the number of girls who have played baseball throughout the years, so there is no way to determine the actual count.

In 1989, Little League established the Challenger Division for boys and girls with physical and mental challenges, ages 4 to 18, or up to age 22 if still enrolled in high school, to enjoy the game of baseball or softball. A new Senior League Challenger Division allows participation regardless of age.

The Little League Urban Initiative began in 1999 to bring baseball and softball programs to underprivileged areas, starting first in Los Angeles and Harlem, New York.

Little League observed the 75th anniversary of its founding in 2014. More than 35 million people around the world, from a US president to community leaders and professional athletes, can call themselves Little League graduates. Every year, millions of people follow the hard work, dedication, and sportsmanship that the Little Leaguers display at nine baseball and softball World Series events, the premier tournaments in youth sports.

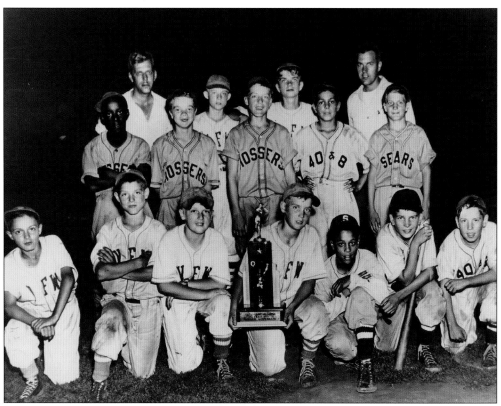

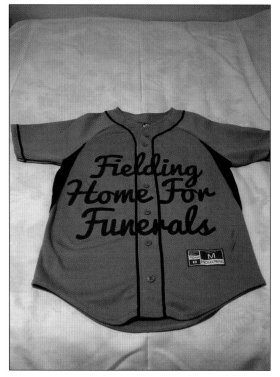

The first team to claim championship status with Little League Baseball was the Maynard Midget All-Stars; the team won the national tournament that later became known as the Little League Baseball World Series. The players on the 1947 team from the Maynard Street area of Williamsport included two African American boys. Shortly after the program began, however, children of all ethnicities were playing baseball.

The Cannon Street Young Men's Christian Association (YMCA) All-Stars from Charleston, South Carolina, the first African American league chartered in South Carolina, got caught in the crossfire of racial tension in 1955. The 61 white leagues, disqualified from tournament play for refusing to play a duly franchised league, regardless of race, left the program and started a new organization. This is a replica jersey from Fielding Home for Funerals, one of the sponsors of the YMCA league.

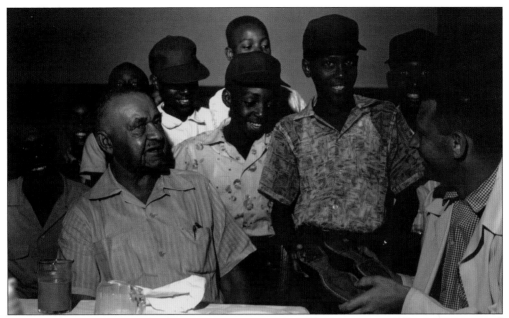

Little League officials brought the Cannon Street YMCA All-Star team to Williamsport to attend the 1955 Little League Baseball World Series as guests. However, the players could not compete because they never won a game in tournament, as required by Little League rules. The team received the same equipment as those playing in the tournament, pictured. Other sponsors in Cannon Street's charter year were Harleston Funeral Home, Pan Hellenic, and Police Athletic.

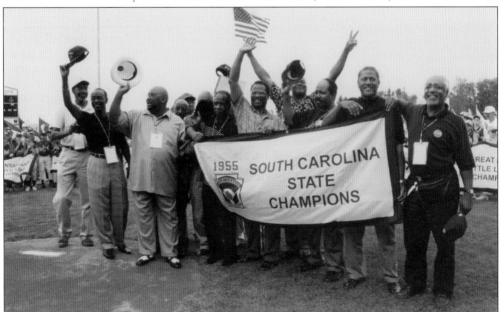

Many of the 1955 Cannon Street YMCA All-Star players returned to the Little League Baseball World Series in 2002 and were recognized by Little League for blazing the trail to give others the opportunity to play. By the time they returned, the Little League Baseball World Series had moved from its location on West Fourth Street in Williamsport across the West Branch of the Susquehanna River to its current location in South Williamsport.

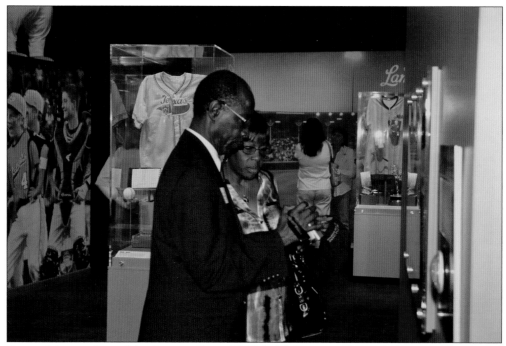

Some of the members of the Cannon Street YMCA All-Star team donated artifacts and attended the museum's grand reopening in 2013. As part of the $4.3 million renovation project, a display dedicated to the team was unveiled. Vermort A. Brown, who wore the No. 1 Fielding jersey proudly in his youth, and his wife, Barbara, were among those attending.

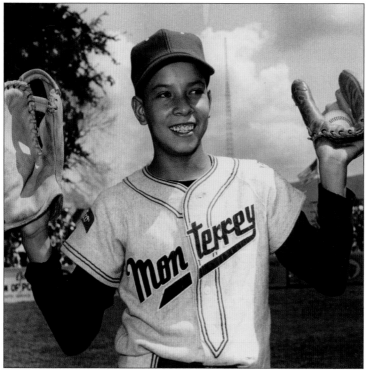

In 1957, Monterrey Industrial Little League from Mexico was the first international team to win a Little League Baseball World Series championship. Museum curator Adam Thompson researched the uniform so it could be re-created for the movie *The Perfect Game*, released in 2009. Adapted from the novel of the same name by William Winokur, the film chronicles the amazing journey of the team to the Little League Baseball World Series. Angel Macias, pitcher, is pictured here.

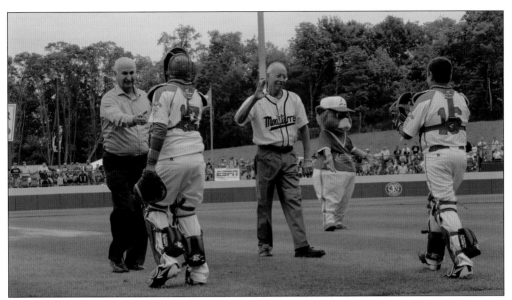

Angel Macias is the only person to have pitched a perfect championship game. His autograph is visible where the brim meets the hat (below). While Macias could pitch effectively with both his right and left hands, he pitched the final game exclusively with his right hand. Monterrey won 4-0 against Northern La Mesa Little League in California. The Monterrey players wore their own jerseys because those available for series players were too large. Monterrey Industrial was the first league to repeat as World Series champions when it returned in 1958. In the photograph above, two catchers congratulate Macias (in yellow) and teammate Jose Maiz Garcia (in blue) after throwing the first pitches at one of the games played by the 2014 team from Guadalupe, representing Mexico.

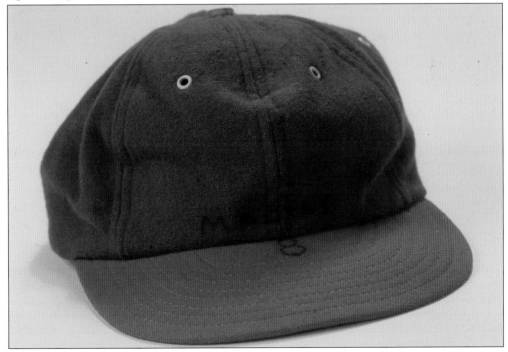

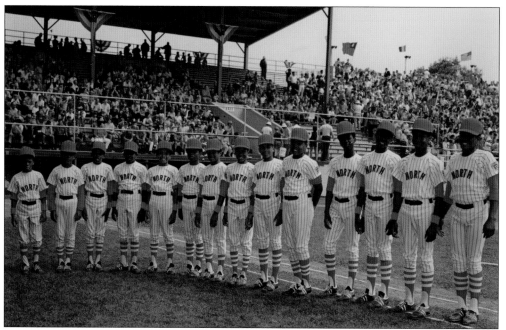

The first African American team to advance to the series was in 1971. The teams from Gary, Indiana, and Tainan, Taiwan, played one of the longest games in Little League Baseball World Series history—2 hours and 51 minutes and nine innings—before the international team won. Lloyd McClendon (far right), a standout player for the Indiana team, is pictured with his teammates.

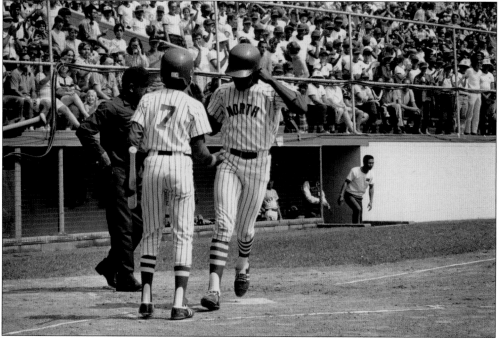

Known as "Legendary Lloyd" at the tournament, McClendon hit five home runs during series play, including this one. McClendon later became a major-league player and is the current manager of the Seattle Mariners; he is a member of the World of Little League® Hall of Excellence.

Major-leaguer Jackie Robinson was at the series in 1962 to provide television commentary on WPIX, New York City. He signed hundreds of autographs and spent some time with the Kankakee, Illinois, team who came in second to the team from San Jose, California. "You can't win them all. I know, I've been in losing series too," the *New York Times* reported Robinson as saying.

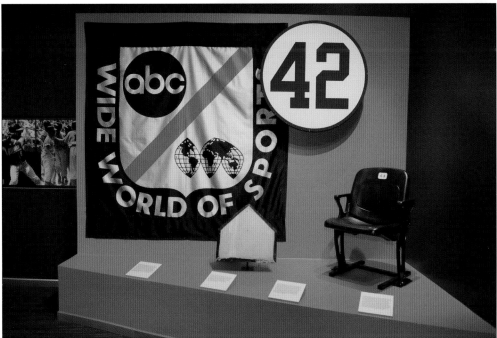

A round disk bearing major-leaguer Jackie Robinson's No. 42 is found hanging in the Fifth Inning (gallery) of the museum. His number was retired in 2007 during a special Little League Tee Ball game at the White House. Also on display are the first home plate used in Lamade Stadium and the *ABC's Wide World of Sports* banner that last was used in 1998. The Little League Baseball World Series was the longest-running event on the program.

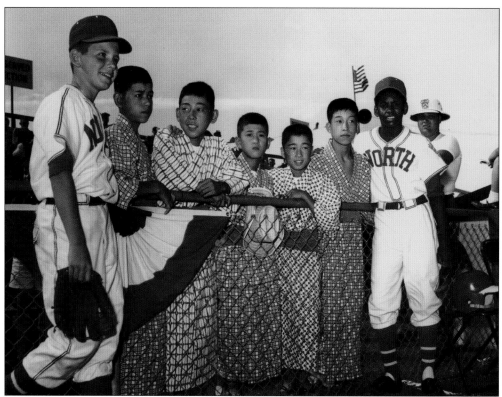

The first Japanese players in the Little League Baseball World Series made a big hit in 1962. Note the traditional kimono garb. Two players from the Kankakee, Illinois, team, representing the North, flank them. The Far East Little League team was from Kunitachi. In 1967, the team from West Tokyo was the first Japanese team to win a Little League Baseball World Series title.

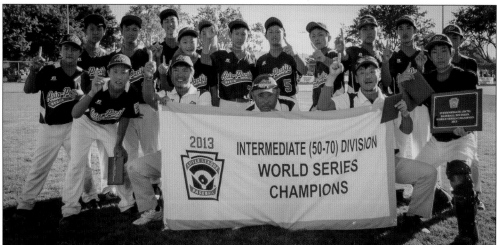

Izumisano Little League from Osaka, Japan, the Asia-Pacific Region champion, won the first Little League® Intermediate (50/70) Baseball World Series, which was held at the Max Baer Park in Livermore, California, in 2013. The division was introduced as a pilot program in 2010. An official division in 2013, it offers a transition from the Little League Baseball diamond size to the Junior League size.

The story of girls playing Little League Baseball begins with Kathryn Johnston Massar, who was known to her teammates as Tubby, a name selected from the *Little Lulu* comic. Envious of her older brother who was trying out for a team in Corning, New York, Massar and her mother tucked her short hair into a baseball cap. She dressed like a boy and borrowed her best friend's bicycle to ride to tryouts for the Kings Dairy team. After Massar made the team, she told the coach that she was a girl. He said, "Well, if you are good enough to make the team, you are good enough to stay on the team." The following year, however, a rule was added stating that girls were not permitted to play Little League Baseball. (Both, courtesy of Kathryn Johnston Massar.)

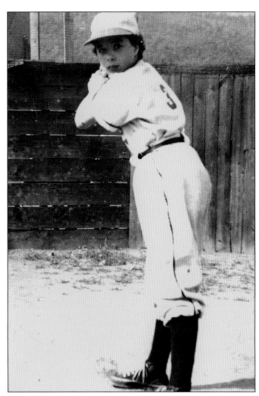

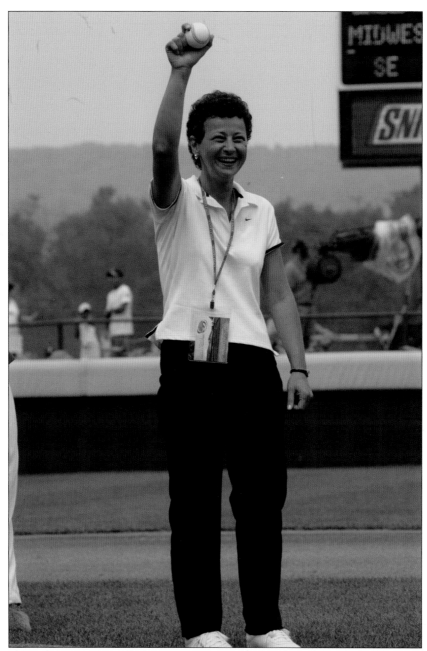

Some girls tried out anyway, including Maria Pepe, whose curly locks peeked out from under her Young Democrats Little League Baseball team hat in 1972. Little League administrators notified the Hoboken, New Jersey, League that its charter would be revoked if she continued playing. Pepe left the team, joining with the National Organization of Women (NOW) to bring a lawsuit against Little League. A federal judge ruled in her favor, but by then she was too old to play. She and others pioneered the way for girls' sports through Title IX legislation. Little League's federal charter was amended in 1974. Softball was added, and girls could play baseball with the boys. Pepe was honored at the 2004 Little League Baseball World Series where she threw out the ceremonial first pitch. Her glove is on display at the museum.

Katie Brownell pitched a perfect game May 14, 2005, in a baseball game in the Oakfield-Alabama, New York, Little League. Brownell did not allow a runner, striking out 18 batters in six innings. Brownell began with Little League Tee Ball when she was five. Brownell said, "There is more to the game than playing the game. There are skills helping with time management and life lessons to be learned."

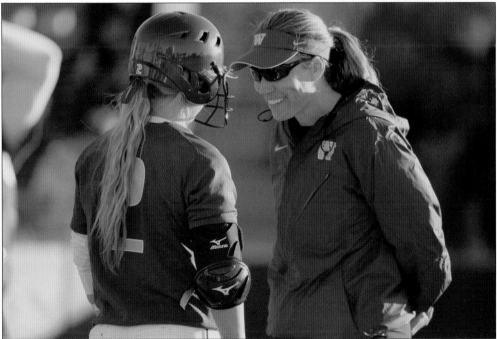

Heather Tarr played on the championship team from Kirkland Little League in Washington District 9 in the Big League Softball World Series in 1993. Her jacket is on display. A player for the University of Washington, Tarr later became the Huskies' head softball coach, winning the college Division I World Series in 2009. In the photograph, Tarr coaches a player. She helps Little League with its instructional softball videos. (Courtesy of University of Washington.)

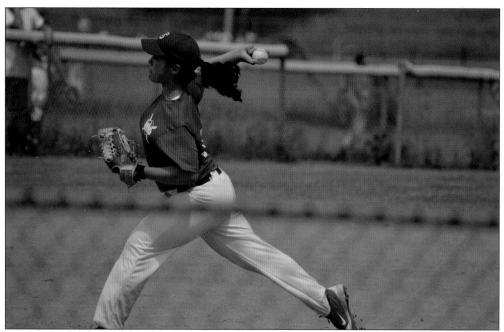

Nadia Diaz played baseball near Syracuse, New York, making headlines when she struck out 19 batters during a Little League game in 2012. "There was a lot of support for me. My whole family, including my mom and grandma, and the crowd were cheering me on." Typically striking out 18 batters finishes a game, but a dropped ball by the catcher in the first inning allowed the player to reach first base. Above, she is seen pitching, and below, Diaz is pictured with teammates Jordan Marcano (left) and Jonathan Vazquez (center). Diaz said she would have been disappointed to learn she could not play because of her gender. "Little League is the reason I fell in love with baseball." Her advice to girls is not to give up on dreams. "Keep trying your best and good things will happen." (Both, courtesy of Jeannette Diaz.)

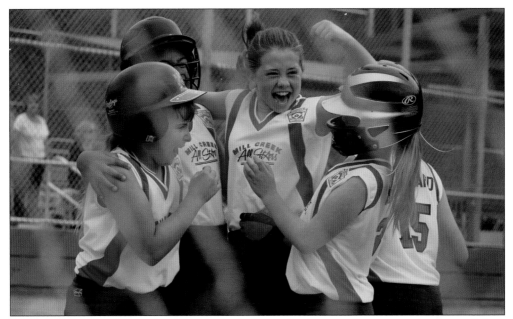

This photograph, submitted in 2010 to Little League's photography contest, depicts a jubilant Mill Creek All-Star team from Washington State cinching a Little League Softball win. Nearly 30,000 girls in the United States signed up in 1974, the first year they were permitted to play baseball and softball. The Little League Softball program now boasts more than 360,000 athletes participating on more than 24,000 softball teams in more than 20 countries.

Victoria Roche, at bat, was the first girl to play in any Little League Baseball World Series. An American, Roche was on the 1984 team from Brussels, Belgium, representing the Europe Region. Roche, her brother Jeremy, and six other Americans joined their teammates from Japan, England, and France on the team from Brussels, where their parents worked at SHAPE (Supreme Headquarters Allied Personnel Europe) for International Telephone and Telegraph.

Pitcher and power hitter Victoria Brucker Ruelas is pictured with the 1989 all-star team from Eastview Little League, San Pedro, California. She was the first girl who started as a pitcher and the first girl who got a hit during series play. She had nine home runs during the run to Williamsport. Her team lost to Maracaibo, Venezuela. An impressed umpire, Betty Speziale, recalled the game, "I had first base, she was playing first, and a kid stole third. She made the play at first and whipped the ball back to home, beating the runner by three feet." Speziale was the first woman to umpire at the Little League Baseball World Series.

Call It Right!: Umpiring in Little League, published three years after Little League Baseball's integration of girls in 1974, gave the following advice: "Women, especially, should go the extra mile to become well trained. Until the sex barrier is completely broken, an element of distrust may still linger in the minds of the current crop of players, coaches, and fans." Pictured is Betty Speziale of Dunkirk, New York, at the Little League Baseball World Series in 1989.

The first woman to umpire behind the plate in a Little League Baseball World Series championship game was Flora Stansberry of Seneca, Missouri, in 2001. That year, the competition expanded from 8 to 16 teams and Volunteer Stadium opened. Unfortunately, that series became the center of a scandal when the team from Bronx, New York, retroactively forfeited every game it had played in the tournament because a player was two years too old.

The first woman to coach a series team was Kathy Barnard, whose son Spencer was on the team from Lynn Valley Little League, North Vancouver, British Columbia. In 1993, she managed the team representing Canada to a win over Saipan. The team later lost to teams from Panama and Germany. Barnard is pictured above with the team she brought to the championship tournament in South Williamsport. In photograph below is the hat that she wore while coaching at the series. Sports were always a huge part of her life, Kathy Barnard told the *Chicago Tribune*, adding that she and her brothers played Little League Baseball. As an adult, she continued to play ball as well as coach.

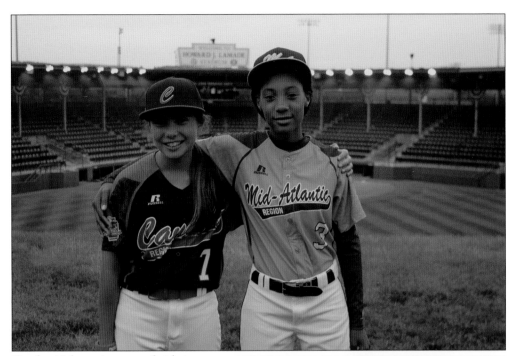

On the 40th anniversary of girls in Little League programs, two were on teams that reached the 2014 Little League Baseball World Series held in South Williamsport, Pennsylvania. Emma March (left), who played for South Vancouver Little League, Valleyfield, Quebec, Canada, and Mo`ne Davis (right), a representative of the Mid-Atlantic Region, were the 17th and 18th girls to have advanced to the championship event. In the photograph at right, Mo`ne Davis, a member of Taney Little League Dragons near Philadelphia, Pennsylvania, is the first girl pitcher to earn a win and pitch a shutout in Little League Baseball World Series history. The Mid-Atlantic team beat the South Nashville Little League team from Tennessee representing the Southeast Region 4-0. She is shown pitching with a hillside of spectators behind her.

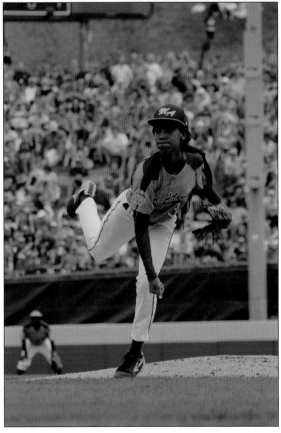

Pennsylvania College of Technology president Dr. Davie Jane Gilmour, above right, made history when she was elected chairman of the Little League International Board of Directors in 2012. "I'm proud to be associated with an organization that plays such a relevant role in the lives of so many children," Gilmour said. As chairman and college president, she has the opportunity "to share in the personal growth of young people, and play a role in their development as they take those first steps into the rest of their lives." Gilmour and Patrick Wilson, senior vice president of operations and program development, left, are pictured with the 2014 series champions from South Korea. In the photograph below, sisters Karen Stotz Myers, left, and Monya Lee Stotz Adkins, right, keep the memories and work of their parents alive by maintaining the Carl E. Stotz Archives. (Below, courtesy of the Carl E. Stotz Archives.)

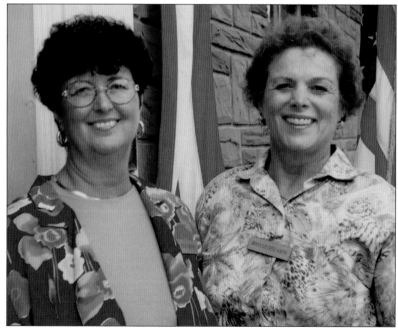

Grayce Stotz stood beside her husband Carl in the formation of the Little League program. Maintaining the baseball fields and teams consumed Carl's spare time, so Grayce and their daughters, Monya Lee and Karen, were there as well. Grayce is the first woman volunteer. This family photograph was taken in 1953 at Watkins Glen, New York. Many of the pieces in the Second Inning (gallery) of the museum are from the extensive Carl E. Stotz Archives. Among those on display are the first home plate, the knife that was broken while carving the plate's thick rubber, a whistle and lanyard used in the first tryouts, the first catcher mask, an invoice for the first baseballs purchased, a sand bucket repurposed for collecting donations at games, and the first rubber pitcher's plate.

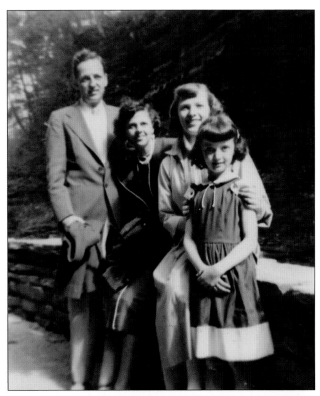

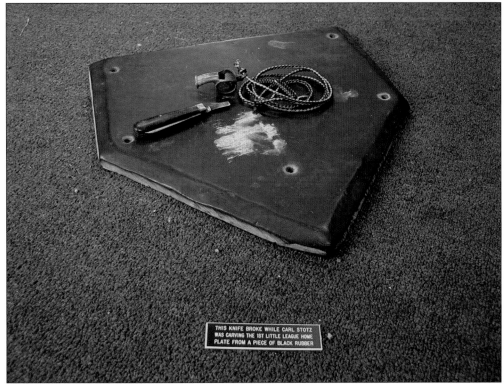

THIS KNIFE BROKE WHILE CARL STOTZ WAS CARVING THE 1ST LITTLE LEAGUE HOME PLATE FROM A PIECE OF BLACK RUBBER

Challenger Division teams are set up according to abilities and require Buddies to assist the Challenger players on the field, but whenever possible, they encourage the players to bat and make plays themselves. Annually, two Challenger Division teams and their Buddies are selected to present an exhibition game at the Little League Baseball World Series. Pictured in 2012 are teams from Chicago, Illinois, and San Francisco, California.

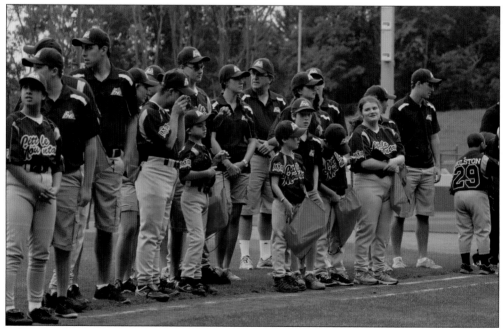

In honor of the 25th anniversary of the Challenger Division, the first international team attended the series in 2014 when a Challenger team from Vancouver, British Columbia, joined a team from Clinton Township, Michigan, just north of Detroit, for the exhibition game. The Challenger Division also holds annual jamborees throughout the United States.

Public Broadcast Station WVIA, serving northeastern Pennsylvania, received a Mid-Atlantic Emmy Award from the national Academy of Television Arts and Sciences for its broadcast of a Challenger Exhibition game in 2011. Ben Payvis II, vice president of WVIA Production and WVIA Studios Global, pictured, received the award in the Human Interest/Special Category. First Community Partnership of Pennsylvania provided funding. Teams from Louisiana and Indiana played in the exhibition.

Baseball Hall of Famer Dave Winfield visits with players during a Little League Urban Initiative Jamboree in 2005. The former outfielder shared stories and techniques with the players. Today, jamborees are held at several locations around the country.

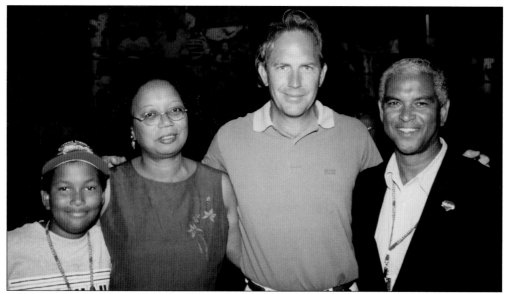

Actor Kevin Costner stands with Iris and Dwight Raiford and their son Joshua during the 2000 Little League Baseball World Series. Dwight Raiford was the first African American elected as chairman of the Little League International Board of Directors, and Iris Raiford was a trustee of the Little League Foundation. The couple founded the Harlem Little League in New York in 1989 as part of the Little League Urban Initiative. In the photograph below, the Harlem All-Stars advanced to the series in 2013, making it to the US semifinal game. The Little League Urban Initiative now operates in more than 200 leagues in nearly 85 cities. It has stimulated the participation of 4,000 teams, about 52,000 players, and has contributed to nearly 30 field renovation or development projects. Major League Baseball, as well as a number of baseball franchises and other organizations, are among the organizations that have supported the initiative.

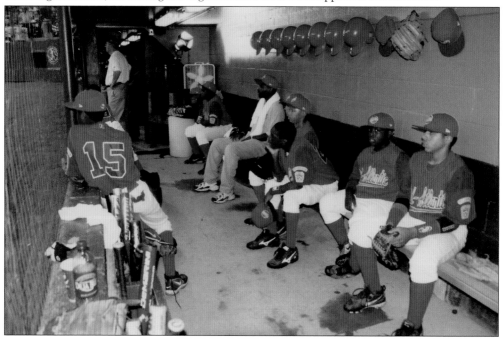

Two

THE BIG LEAGUE AND HIGHLIGHTS

Little League games have drawn millions of players, volunteers and spectators since 1939. Some included television or sports personalities. Among the notables at the Little League Baseball World Series are Cy Young, Connie Mack, Gary Carter, Kent Tekulve, Nolan Ryan, Jackie Robinson, and Mike Mussina, as well as announcers like Jim McKay and Howard Cosell. More recent announcers include major-leaguers Orel Hershiser, Barry Larkin, and Nomar Garciaparra.

Another well-known baseball player, George Herman "Babe" Ruth, was "grounded by children," according to his granddaughter Linda Ruth Tosetti when she provided commentary for the World of Little League's audio tour guide about the most complete uniform worn by Ruth.

She said it was not unusual for Ruth to leave dinner early if he saw a sandlot game and hit a couple of balls with the kids. "I have this from information from people who knew him. He really had an effect on kids that was miraculous." Her mother told her that Ruth would visit hospital wards. Youngsters who could not sit up, would sit up, and those who could not walk, would run after him. "He talked about good sportsmanship, taking care of your body, eating properly and having your teammate's back. If you work hard, you can have whatever you want," Tosetti said.

"There is perhaps no name connected to baseball that is more recognizable around the world than Babe Ruth," Stephen D. Keener, president and chief executive officer of Little League Baseball and Softball, said when the uniform arrived for display at the museum. "Even after all these years, people know his name."

In addition to the Ruth uniform, the museum has other one-of-a-kind artifacts, items commemorating "firsts," and rare film footage throughout its Six Innings (galleries). There are highlights of many of the Little League Baseball World Series games and more recent footage of the other divisions' series play.

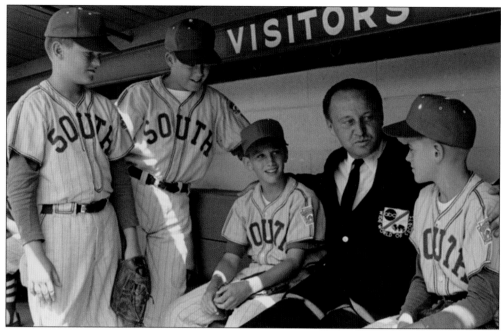

Former ABC sports personality Jim McKay was the play-by-play voice for 11 Little League Baseball World Series championship games from 1964 to 1985. In this photograph, McKay chats in the dugout with members of the Westbury American Little League, Houston, Texas, during the 1966 series.

Former left fielder for the Boston Red Sox, Ted Williams was the announcer for ABC during the 1967 Little League Baseball World Series. He is regarded as one of the greatest hitters in baseball history. That year, West Tokyo, Japan, was the first Far East team to win a series championship.

A famous major-leaguer attending the Little League Baseball World Series was Carlton Fisk, a Baseball Hall of Famer (2000). Fisk was in the broadcast booth in 1975. A catcher, Fisk played for the Boston Red Sox and the Chicago White Sox. More recently, Fisk was the grand marshal of the Grand Slam Parade in Williamsport, which kicks off the 10 days of activities of the series.

Earl Weaver, center, attended the Little League Baseball World Series twice. In this photograph he shares the ABC's *Wide World of Sports* broadcast booth with Hall of Famer Jim Palmer, right. When Weaver managed the Baltimore Orioles, Palmer was his most dominant pitcher. A former Little Leaguer, Palmer is a member of the Hall of Excellence.

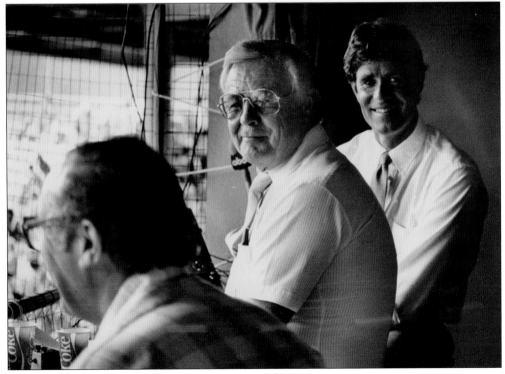

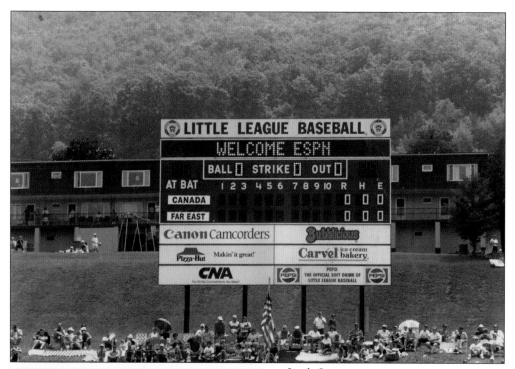

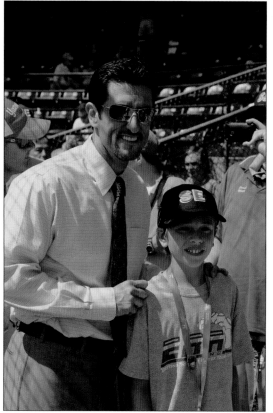

Little League tournaments are among the most popular summer programming for the ESPN family of networks. ESPN provides coverage for all of the divisions of play, including regional tournaments. ESPN produced a Vignette Series that aired throughout 2014. The short-form retrospectives featured some of the most significant moments and important people in Little League's 75-year history. They can be seen on YouTube.com/LittleLeague. In 1982, Little League welcomes ESPN, pictured.

Nomar Garciaparra is a member of an ESPN announcing team that comes to the Little League Baseball World Series. He is pictured with a fan. Brent Musburger, Orel Hershiser, Karl Ravech, Gary Thorne, Bobby Valentine, Jon Sciambi, Adriana Monsalve, and Kyle Peterson also have appeared much to the delight of young and old fans.

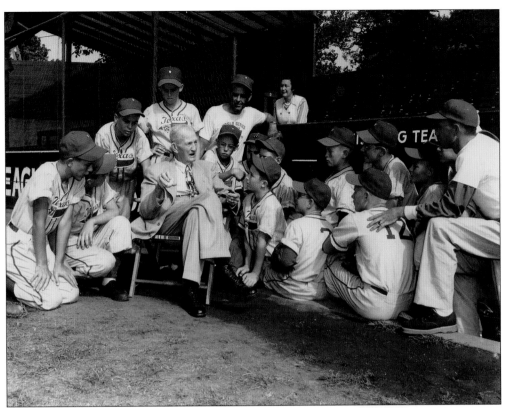

Baseball great Cy Young was happy to share pitching techniques and stories with Little Leaguers. Steadfast friends since first meeting in 1951, Carl Stotz served as a pallbearer at Young's funeral in 1955. The exhibit about Young includes a set of collector's cards and a souvenir wooden bat turned from the last tree that he felled. Even in his 80s, Denton True Young found cutting wood relaxing.

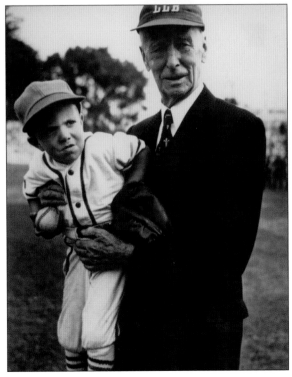

The mascot for the 1952 team from Norwalk, Connecticut, was Billy Morgan, held here by baseball giant Connie Mack, the longest-serving manager in Major League Baseball history. A major-leaguer, Mack later owned a baseball franchise. By this time, Little League had expanded to more than 15,000 programs.

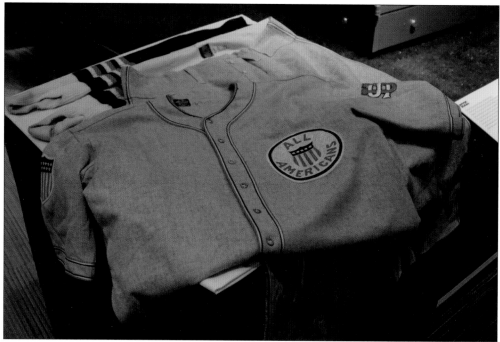

George Herman "Babe" Ruth did not play Little League, yet he continues to impact today's youth. On loan are the three pieces to the only uniform that Ruth wore on his sole international barnstorming tour in 1934. The gray uniform, trimmed in red, white, and blue, bears his No. 3 and the insignia of the All-Americans. In the photograph below, "B. Ruth" is embroidered on the waistband. The uniform is considered to be one of the most important and collectible sports items in the world. According to research, the largest rickshaw traffic jam in Japan's history occurred in Tokyo when The Babe entered Japan for a series of exhibition games, teaming up with Lou Gehrig, Jimmie Foxx, Connie Mack, and Lefty Gomez. More than 500,000 Japanese attended the 18 games and saw Ruth hit 13 home runs.

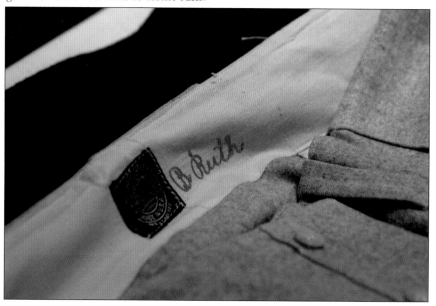

A baseball on display at the museum and autographed by the Sultan of Swat was hit during a barnstorming tour in Williamsport just after the New York Yankees won the 1923 World Series. Practicing at Grays Park, Babe Ruth blasted the ball 500 feet. The West Branch Valley Sports Hall of Fame gifted the ball in 1984. In this superimposed photograph, granddaughter Linda Ruth Tosetti strikes a familiar pose as her grandfather. (Courtesy of Linda Ruth Tosetti.)

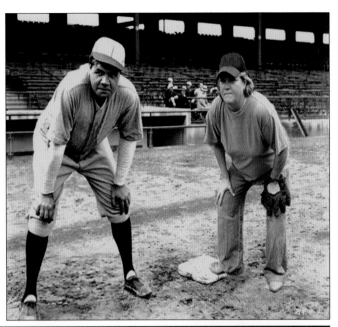

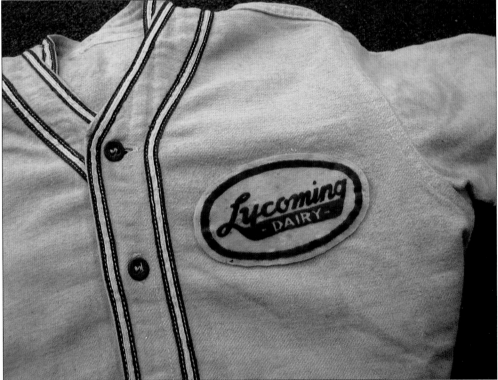

Babe Ruth's jersey may be the most famous on display at the museum, but others have interesting stories too. The oldest Little League uniform is from the Lycoming Dairy team, one of three teams formed by founder Carl E. Stotz in 1939. It and teams sponsored by Lundy Lumber and Jumbo Pretzel included 30 boys and some adults who were committed to the program's success. The other managers were brothers Bert and George Bebble.

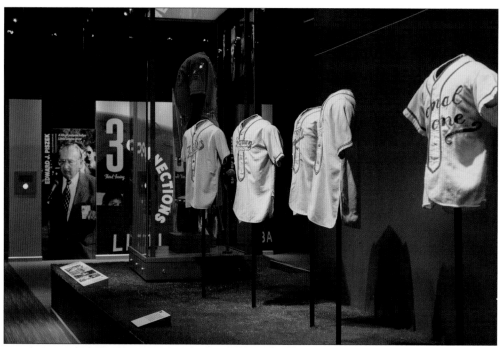

In the second year of organized play, Lundy Lumber and Lycoming Dairy were joined by teams sponsored by Stein's Service Station and Richardson Buick. Lundy Lumber has sponsored at least one team each year since Little League began. Initially, each team cost $30 to outfit. A jersey from a team from Panama is at far right.

The jersey and jacket worn by catcher Gary Carter of the West Fullerton Little League in California in 1966 is on display. Carter received the 1993 William A. "Bill" Shea Distinguished Little League Graduate Award for exemplifying the spirit of Little League Baseball. Inducted into the National Baseball Hall of Fame in 2003, Carter attended the Little League Baseball World Series in 2010. He is pictured at left with his father, Jim, the Little League Parent of the Year in 1985.

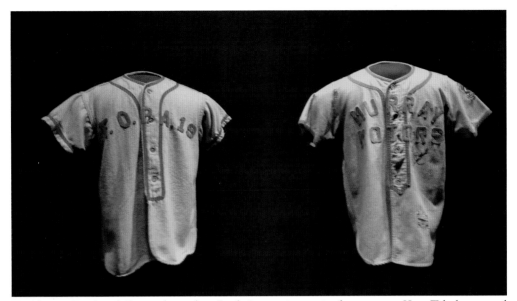

Two former Pittsburgh Pirates have their Little League jerseys in the museum. Kent Tekulve started playing in the Lindenwald Little League in Hamilton, Ohio, at nine years old. Tekulve received the Bill Shea Distinguished Little League Graduate Award in 2008. The Murray Motors jersey on display is from Pirate Ed Ott, who lived in Muncy, Pennsylvania, only a few miles from the place where Little League began in Williamsport.

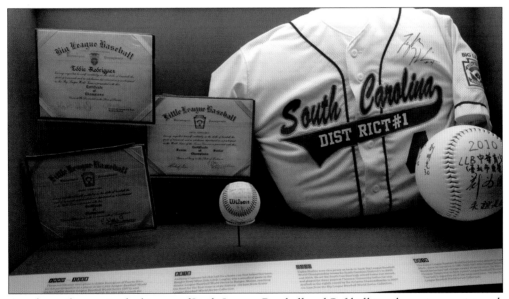

Another milestone in the history of Little League Baseball and Softball involves a jersey, pictured, worn by Taylor Harbin, who played back-to-back World Series in Big League Baseball, a division for older players. Harbin played for South Carolina District 1 teams, which won the titles in 2003 and 2004. Harbin, drafted by the Arizona Diamondbacks, relays his Little League experiences as part of the exhibit.

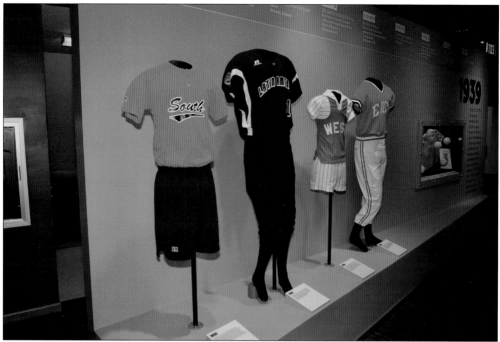

Softball uniforms shown in the above photograph are from a variety of years. Uniforms are from the San Juan, Puerto Rico, 2012 Big League Softball World Series; US West team from Medford, Oregon, 1975 Little League Softball World Series; District 12 team from Williamsport/Lycoming County, 1994 Big League Softball World Series; and Midway Little League of Waco, Texas, 1999 Little League Softball World Series. Midway won more championships (10) than any other league. The short shorts and a poufy cap uniform worn in 1975, below, later gave way to longer shorts and jerseys and then to pants similar to what are worn by Little League Baseball teams today.

Perhaps, the most well-known umpires in Little League were Howard Gair and Frank Rizzo. Gair umpired nearly 500 games in 17 years. Rizzo umpired from 1947 through 1988. In 1985, Rizzo made baseball history when he was the first baseball umpire to wear a miniature camera attached to his face mask. The battery pack was strapped to his back. Film footage is on view.

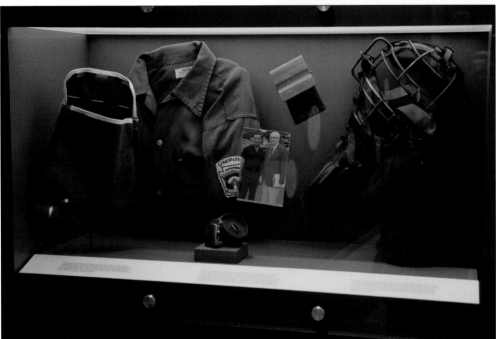

This US Army Airborne grenade and ammunition pouch was repurposed as an umpire's baseball bag. The Army web belt was dyed blue, along with a set of fatigues, so that the umpire was dressed the part. They belonged to Army captain Daniel J. Cleary Jr., a volunteer Little League umpire and veteran of World War II and the Korean War, when he was stationed at Fort Richardson, Alaska.

The team from Williamsport, Pennsylvania, turned a triple play with this softball in the 1985 Big League Softball World Series championship game against a team from Dayton, Ohio. With runners at first and second and no outs, third baseman Melissa Kennedy and first baseman Tami Dickey combined on the rare feat, helping Williamsport to its second consecutive title. This jersey is signed by the team from the Philippines; the first non-US team to win the Big League Softball World Series.

The first Little Leaguer to throw a no-hitter during a game at the Little League Baseball World Series in Williamsport was Billy Martin, a member of the 1950 Houston, Texas, team. Two days later, Martin threw a one-hitter to help his team cinch the championship. In this photograph, Martin is hoisted onto his teammates' shoulders in celebration. It was the first time a team from Texas entered the tournament.

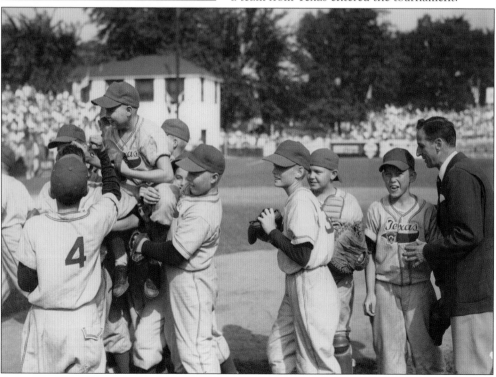

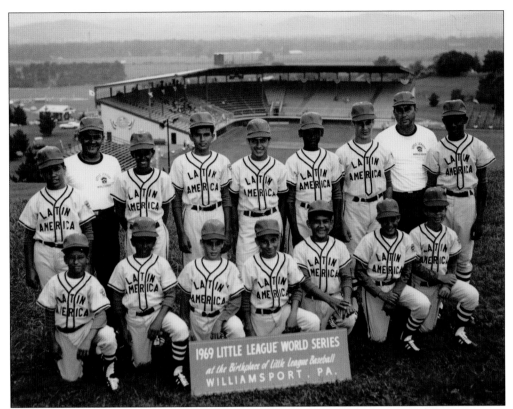

1969 LITTLE LEAGUE WORLD SERIES
at the Birthplace of Little League Baseball
WILLIAMSPORT, PA.

Eddie Rodriguez played in a Little League Baseball, Senior League Baseball, and Big League Baseball World Series in 1969, 1971, and 1973, respectively. He also played in the minor leagues for the Los Angeles Dodgers as Eddie Rodriguez Fajardo. He coached teams from Puerto Rico in the Big League Baseball World Series tournaments in 1983, 1985, 1986, 1990, and 1993. There are "moments that are forever in my memory from my participation in Little League," Rodriguez wrote when he donated his three Little League Baseball World Series diplomas. In 1971, pictured at right, he pitched a shutout against Mexico. "I remember having hit a triple in the World Series in 1973. When I reached third, the announcer said it was my birthday." (Right, courtesy of Eddie Rodriguez.)

The life of Little Leaguer Christina-Taylor Green, one of six people killed in 2011 during an assassination attempt on Arizona congresswoman Gabby Giffords, is highlighted in a video aired on ABC. Born September 11, 2001, Green was featured in a book about babies born that day. Members of New York City's Fire Department attended her funeral, presenting an angel sculpture fashioned from the ruins of the Twin Towers. To keep her spirit alive, Canyon Del Oro Little League designed a patch and Green's family had note cards printed of a butterfly that she had drawn. That year, 2011, was the 10th anniversary of 9/11, and the families of Green and Hall of Excellence inductees Michael Cammarata, Wilbert Davis, and Ross McGinnis were honored by Little League during a ceremony.

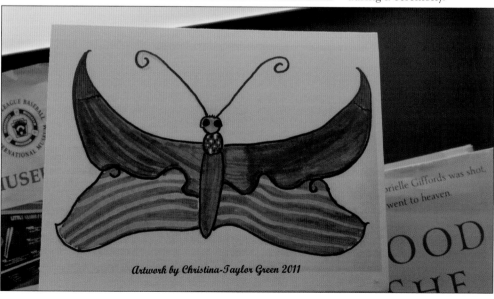

Artwork by Christina-Taylor Green 2011

Richard "Hank" Bauer Jr. hit a game-winning home run for the Newville, Pennsylvania, team in the 1952 Little League Baseball Pennsylvania State Tournament at the Original Little League Field in Williamsport. For decades, Bauer recalled and shared his experiences of that proud moment when he crossed home plate. His daughter Jill is seen standing next to a photograph of him. The museum's photograph gallery is dedicated in his memory. The gallery includes photographs from an annual photography contest sponsored by Little League.

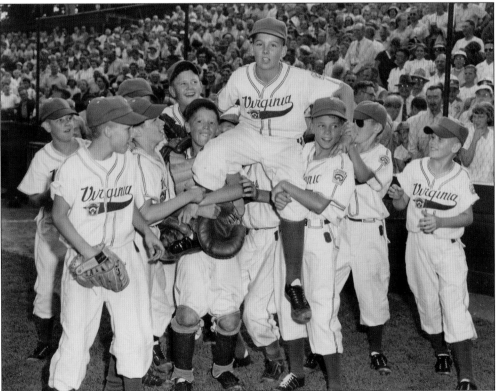

When the Front Royal, Virginia, all-star team squared off in extra innings in 1953 against the all-stars from Vancouver, Sam Cooksey was the pitcher. "I pitched eight innings against Canada and got the base hit to win the game," said Cooksey, who threw a two-hitter. "Those were the best days of my life," he reminisced, eyes misting and sparkling as he recalled receiving individual pitching instruction from baseball great Cy Young.

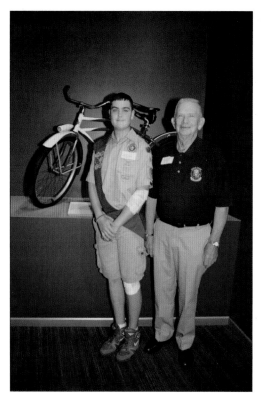

Seeing this bicycle, restored to its original splendor by Boy Scout Troop No. 66 of Woolrich, Pennsylvania, brought a flood of memories to owner John Heckman, who was on the 1949 Lock Haven Little League championship team. The Lock Haven team received bicycles on behalf of the townspeople and merchants to commemorate the team's feat. Years later, Heckman donated it to the Clinton County Historical Society/Heisey Museum, and it is on loan.

California's Russ Tinsley volunteered as Little League's official photographer at a variety of functions, including the series. When not taking photographs at Little League functions, Tinsley worked on sound production for dozens of television and film projects, including the television show *Mr. Ed.* Tinsley's Emmy Award in 1986 for Sound Editing for a Miniseries or Special is on display. It is one of two Emmy Awards in the museum.

Among the museum's peculiar artifacts is a dental articulator that was made by a volunteer when he was in dental school. Dr. Michael "Doc" Lantiere has volunteered for more than 35 years at the local level. He umpired at the 1995 Little League Baseball World Series and now serves as assistant Eastern Region umpire-in-chief. Each year, Lantiere volunteers as a host for the umpiring crew in South Williamsport.

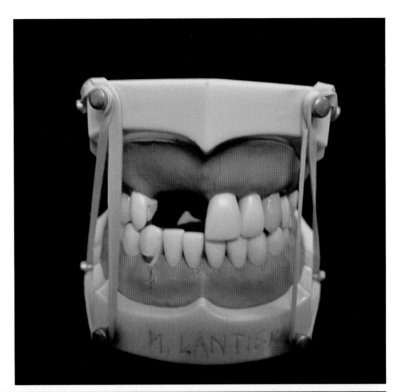

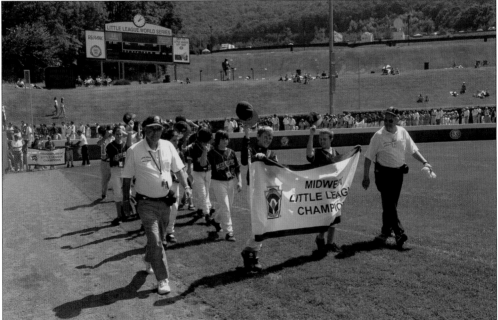

Hosts play a crucial role at the Little League Baseball World Series. Men and women, known as uncles and aunts, volunteer to help the teams, forge relationships with the players, and make sure the youngsters have fun. Fred Plankenhorn, right, served as a host with Paul Weaver, left, for many of his 44 years as a volunteer. He owned Plankenhorn's Stationery company and had a radio show for 55 years.

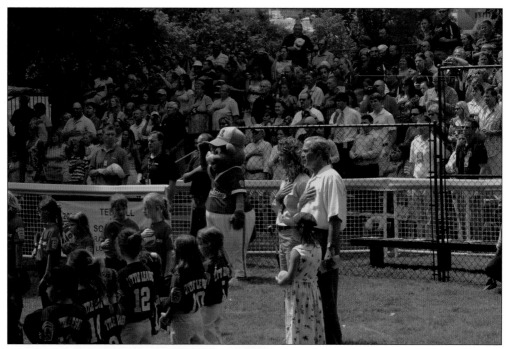

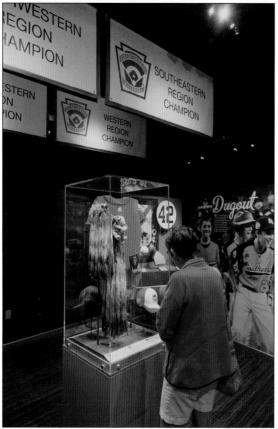

The benches in the Dugout Theater at the museum are from Lamade Stadium, where the Little League Baseball World Series has been played since 1959. Prior to the theater, the benches were used for the 20 Tee Ball on the South Lawn games at the White House during US president George W. Bush's tenure, as shown in photograph. The Dugout Theater spotlights a movie about the Little League Baseball World Series.

The strands of rainbow-color origami are symbols of good fortune; called Senbazuru ("thousand cranes"), they were created by the parents of the 2010 Little League Baseball World Series team from Edogawa Minami Little League, Tokyo, Japan, each time the team advanced. The Long Beach, California, teams from 1992 and 1993, which were the first to earn back-to-back Little League Baseball World Series titles, had a troll doll for good luck as well as Sean Burroughs, who went on to play Major League Baseball. His father, Jeff Burroughs, a former major-leaguer, was coach.

Little Leaguers lined the streets of Williamsport and South Williamsport in 1996 to toss a baseball from Original League, where the first series was played, to Lamade Stadium to begin the 50th anniversary celebration. It was tossed from player to player for four miles. Here, the ball is being tossed across the West Branch of the Susquehanna River.

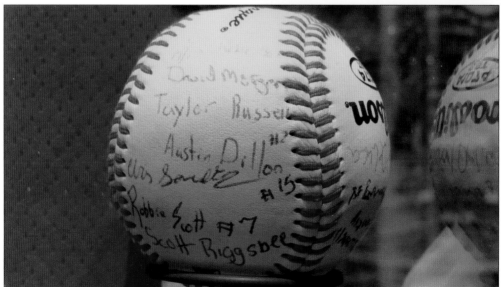

Not all Little Leaguers become major league players, even if they make it to the Little League Baseball World Series. Austin Dillon, now a NASCAR driver, and his teammates from Forsyth County (North Carolina) signed this baseball in 2002. The grandson of Richard Childress, a prominent name in motorsports, said his favorite memories are carrying a flag during opening ceremonies and, of course, how close he and his teammates became.

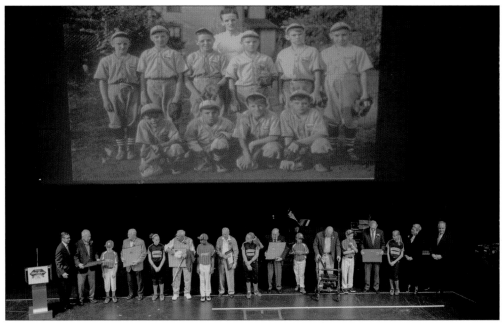

To commemorate the 75th anniversary of its founding, Little League Baseball and Softball sponsored a number of special events, including one at the Community Arts Center in downtown Williamsport, Pennsylvania. Players from 1939 were honored on stage. Players from 2014 assisted them.

When Little League International added to its administration building in 2009, a time capsule was placed in its foundation to be opened in 50 years. Its "messages to the future" replace those found during construction that had been placed in a metal coffee can in 1960 when the building was erected.

Three

LITTLE LEAGUE®
PROMOTES SAFETY

Since the beginning, Little League has emphasized that the health and safety of its players, volunteers, and spectators are more important than winning. To that end, it has pioneered a number of improvements and regulations to protect those who are at a game. Pitchers follow Pitch Count Rules, which require mandatory rest after a certain number of pitches while ASAP (A Safety Awareness Program) shares ideas that have improved safety at local leagues. The grassroots program based on communication of ideas began in 1994.

Founder Carl E. Stotz worked with US Rubber Company's Goodyear Metallic Rubber Shoe Company to develop a better shoe for players who were not permitted to wear spikes; sneakers did not provide good traction on wet fields.

It was a safety issue that first drew Dr. Creighton Hale to Little League. The inventor and scientist had read a newspaper article about the organization wanting to develop helmets to protect players. An associate professor at Springfield College in Massachusetts, Hale recognized the need for research into the safety requirements of Little League Baseball and the effects of athletic competition on young boys. In 1955, he was granted a leave of absence from Springfield College and joined the Little League Baseball headquarters staff as its director of research.

A pioneer in the development of youth sports equipment, such as the double ear-flap batter's helmet, catcher's helmet, chest protector with throat guard, and the non-wood baseball bat, Hale contributed significantly to the phenomenal growth of Little League. He initiated and implemented a drug and alcohol education program, international expansion of Little League to more than 80 countries around the world, a traffic safety initiative in partnership with the US Department of Transportation, and an anti–spit tobacco initiative in partnership with the National Cancer Institute, to name a few.

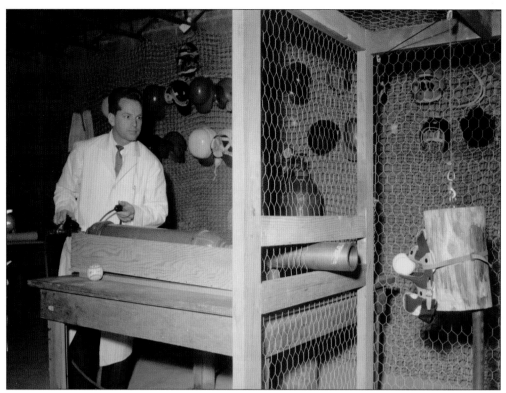

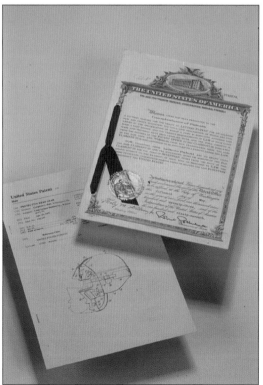

A cannon activated with compressed air designed by Dr. Creighton Hale hurled balls at face masks and helmet prototypes on a wooden head to determine the best design so head injuries could be reduced. Helmets, face masks, and other safety equipment evolved during his tenure as researcher, president, and chief executive officer. Additionally, the military consulted with Hale to help develop the Kevlar helmet that has protected many soldiers' heads. The cannon is on display at the museum.

Dr. Creighton Hale parlayed his experiments into a full-time position with Little League and developed other safety gear for players. His safety measures are patented, and Little League International receives the royalties. Hale retired as president in 2001 and from the board of directors in 2014 after nearly 60 years.

One of the oldest baseballs known to exist, from around 1868, is part of a case devoted to baseball equipment from the early years of the sport before it was scaled down to fit 9- to 12-year-old players. The ball is displayed with a three-fingered mitt from 1914, a catcher's mask from 1918, and a heavy wooden bat from the 1930s. The first base used in the Little League program was hand sewn and stuffed with excelsior (wooden shavings) obtained from a drugstore.

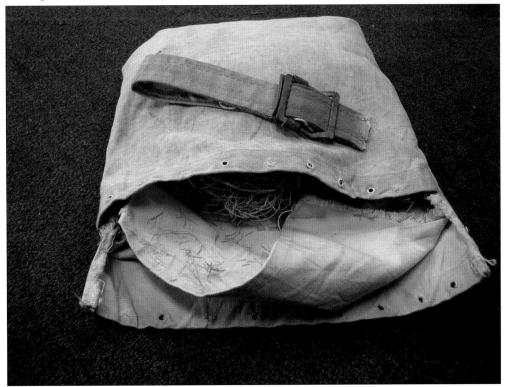

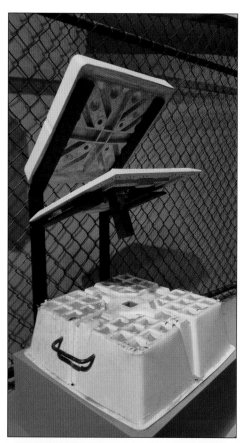

Little League's penchant for safety extends beyond personal equipment to the field itself. Bases that disengage the anchor are mandatory at all levels, like this one that was used in Little League Baseball World Series games at Lamade Stadium. The system allows the base to remain in place when stepped on, but disengages when sufficient force is applied to the side. It is shown disassembled.

A foul ball hit during the 2012 Little League Baseball World Series broke this lens cover protecting ESPN's high-definition camera, valued at $10,000, during a game at Lamade Stadium. The television games are now a staple of August programming on ESPN's networks. ABC's *Wide World of Sports* carried the final game from 1963 through 2005. Today, every game of the series is televised. The first telecast of the series was in 1953 on CBS.

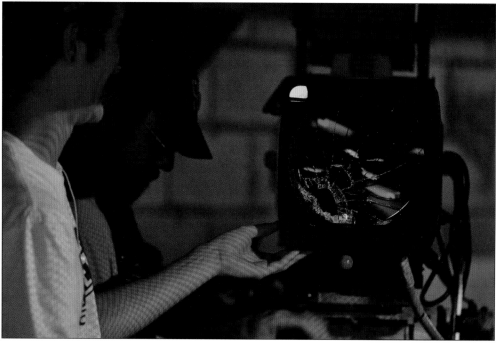

Four

LITTLE LEAGUE® HOLDS
INTERNATIONAL APPEAL

Little League Baseball and Softball is played on six of the seven continents. Only Antarctica has not held an official game. However, at least two Little League program baseballs were taken there, including one by Craig Johnson when he was district administrator for California District 7.

However, those are not the only baseballs with Little League connections in remote locations. There is one orbiting around the Earth in the International Space Station. In 2010, that baseball was "thrown" as part of the opening ceremonies before the first game at the Little League Baseball World Series championship.

The video of astronauts throwing the baseball in outer space for the first pitch sprung out of a relationship developed with the National Aeronautics Space Administration (NASA), with the help of Col. Terry Virts, an astronaut who piloted the space shuttle *Endeavour* to the International Space Station that spring, and representatives from Marshall Space Flight Center in Huntsville, Alabama, who were planning a traveling exhibit's stop at the museum for the 2010 series.

As part of his voyage, Virts, a Little League coach, took a Little League Keystone patch to the station and later donated it to the museum. Although the baseball actually remains inside the International Space Station, it is featured in a video developed by NASA for the opening ceremonies.

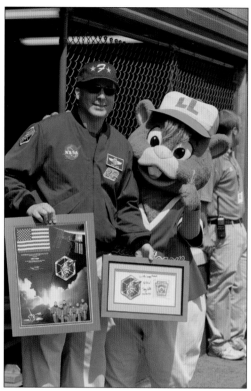

While visiting the Little League Baseball World Series, Col. Terry Virts presented a Keystone patch and space shuttle flight patch (STS-130) and shared the values of a good education with the players. He is shown in this photograph with Dugout, Little League's mascot. Virts also participated in the Grand Slam Parade, which is held in Williamsport before the series games begin. The parade began in 2005.

Col. Terry Virts coached a team from Texas that lost against some of the all-stars from the Pearland White Little League, pictured. Although Virts's team failed to advance in tournament play, the Pearland White team clinched the Southwest berth in 2010. So, instead of attending with his team, Virts attended the World Series on behalf of NASA and supported the Pearland White Little League.

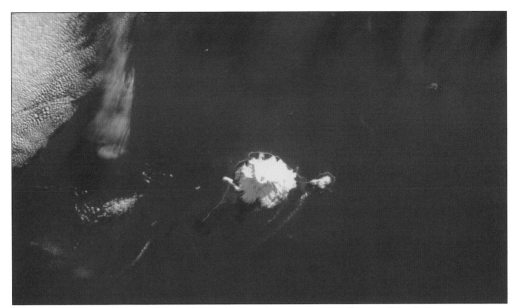

Antarctica, the only continent in the world that does not have a chartered Little League, appears very desolate and cold in this view from space. (Courtesy of NASA.)

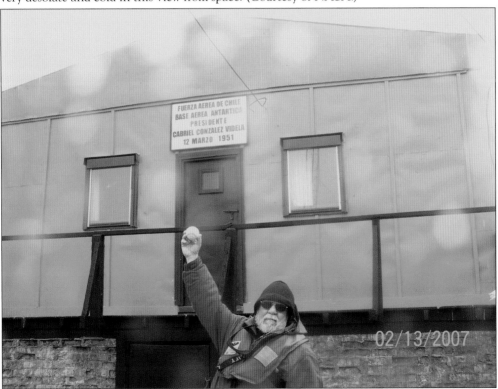

A Senior League baseball is held high by a retired IBM employee and Little League district administrator who trekked to Antarctica in 2007. Craig Johnson made four stops, including Antarctic Base Gabriel Gonzalez Videla, which is named after the Chilean president Gabriel Gonzalez Videla, who, in the 1940s, was the first chief of state to visit the continent.

The Chinese Taipei contingent consistently filled a section of Lamade Stadium at the series games in South Williamsport, Pennsylvania, during a winning streak from the 1960s to 1996. Chinese Taipei won 17 championship titles there, and 17 each in Big League and Senior League Baseball Divisions. Then the country dropped out of the program until 2003, when the Chinese Taipei Baseball Association renewed charters for 15 leagues.

With the fall of the Berlin Wall, Little League programs spread rapidly. Pictured are, from left to right, Stan Musial, of the St. Louis Cardinals (1941–1963); unidentified; and Edward Piszek, who cofounded Mrs. Paul's Kitchens. Piszek was instrumental in starting a program and establishing a regional center in Kutno, Poland. The exhibit includes a silk baseball cap and an empty fish stick box cover.

Opening day ceremonies at Volunteer Stadium in South Williamsport, Pennsylvania, in 2012 bears special significance to a team from Lugazi, Uganda. It was the first time a team from Africa represented the Middle East and Africa Region in the Little League Baseball World Series. Their 4,000-mile trip included nearly 18 hours of flight time and four hours on a bus. After arriving, the team, along with the 15 other Little League teams, received brand new equipment.

Visitors have the option to leave a message or their hometown on the World of Little League Museum's autograph ball. Many Little Leaguers choose to give their names and jersey numbers or comment about the museum.

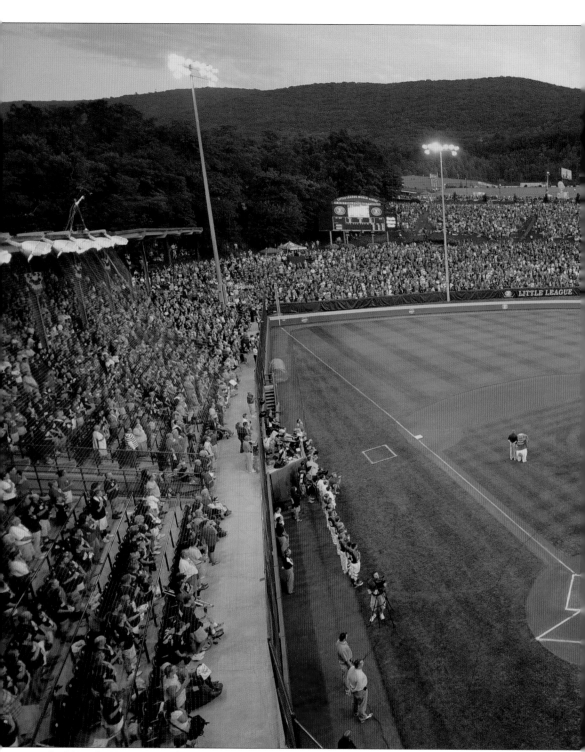

In 2011, the Keystone Little League from nearby Clinton County was the first area team to advance to the series in South Williamsport since Newberry Little League of Williamsport did in 1969. One of the team's games drew a "sea of blue" record crowd of 41,848 to Lamade Stadium. A hat

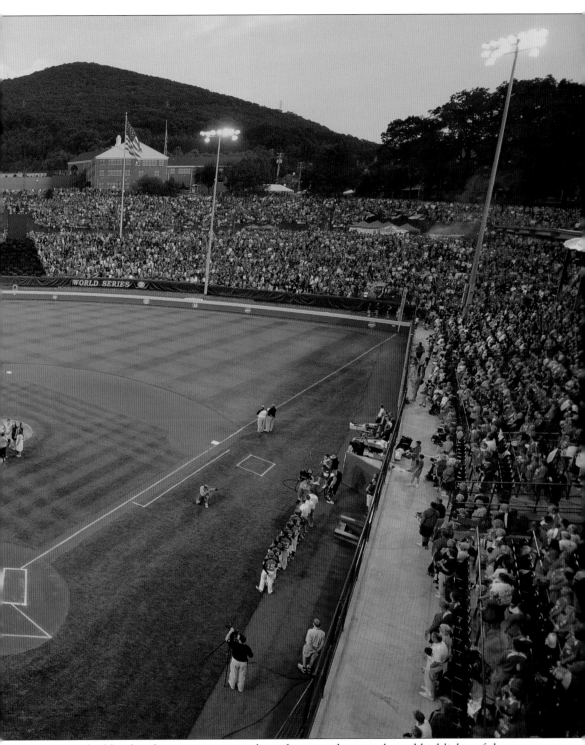

autographed by the players, manager, and coach; team photograph; and highlights of the game can be seen at the museum in the Fifth Inning (gallery). There are no fees to attend World Series games. A donation bucket is passed just as it is at the local level.

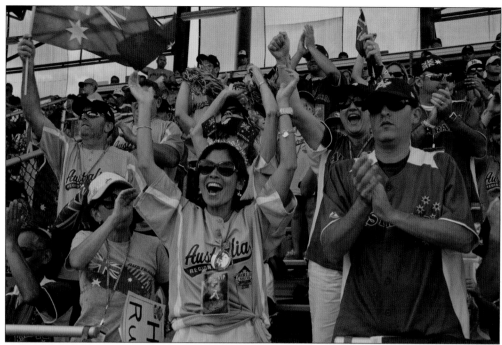

In 2013, the Little League Baseball World Series hosted the first team from Australia. The boundaries of the 16 regions for series play were realigned, giving Australia an automatic berth. The regions are based on participation at the local league level. There was tremendous growth at that level, making Australia the fourth-largest country to play Little League. In the photograph, fans cheer for the team in a game against the Caribbean Region.

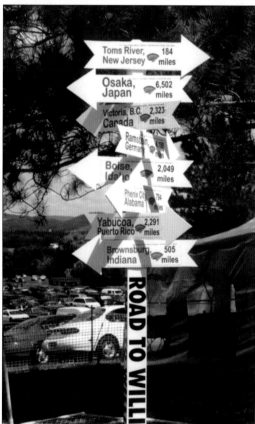

The road to the Little League Baseball World Series becomes visual when the directional arrows are placed on the Little League International Complex in South Williamsport, Pennsylvania. Since the addition of leagues in Australia in 2012, teams traveling from there have the longest journeys of any group.

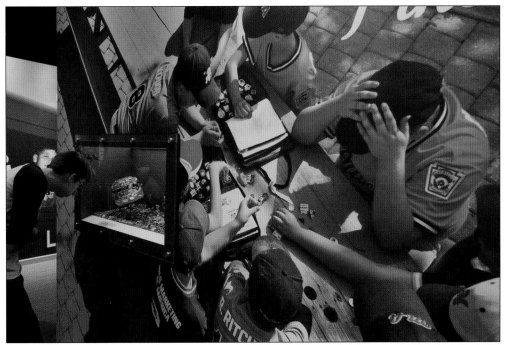

Pin trading is a favorite pastime at the Little League Baseball World Series, both on and off the complex. Pictured is a visitor admiring a hat filled with pins once worn by Cliff Glier, an avid pin collector who was the public address announcer for the series from 1968 until he died in 1993. Glier was the first district administrator for Virginia District 10. Teams, as well as visitors, bring pins to trade.

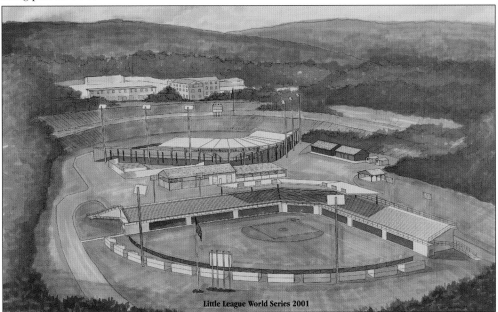

Little League World Series 2001

This artist's rendering shows the addition of Volunteer Stadium in 2001. The extra stadium supported the expansion of the Little League Baseball World Series from 8 teams to 16. Now eight are from the United States, and the remaining eight are international.

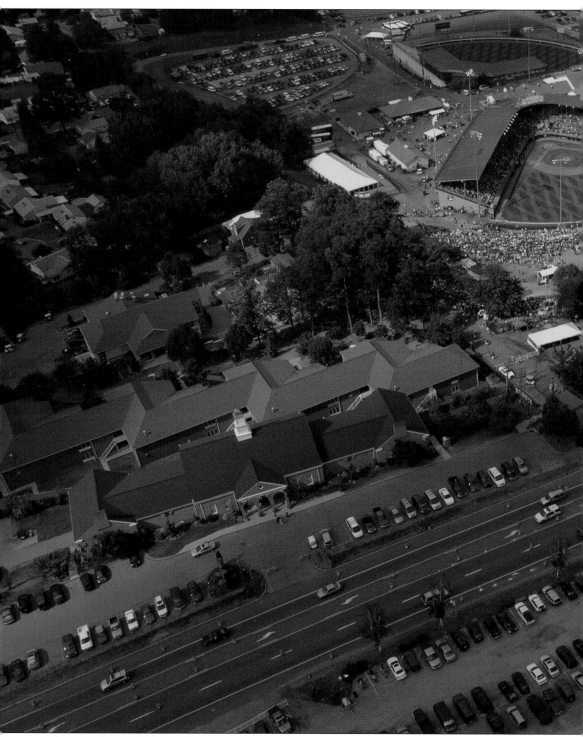

This aerial view of the Little League International Complex was taken in October 2008. The World of Little League Museum is at left along Route 15. The Creighton Hale International Grove with the dining hall, dormitories, and swimming pool is directly behind it. The administration

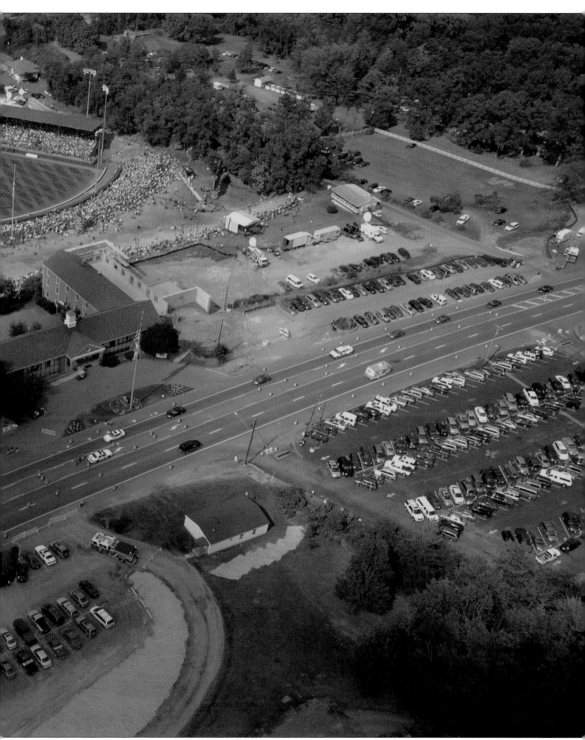

building, under construction, is on the right. Since 1959, the Little League International Complex has grown from 22 acres to more than 70. Lamade Stadium, where the Little League World Series Championship game is played, is larger than Volunteer Stadium.

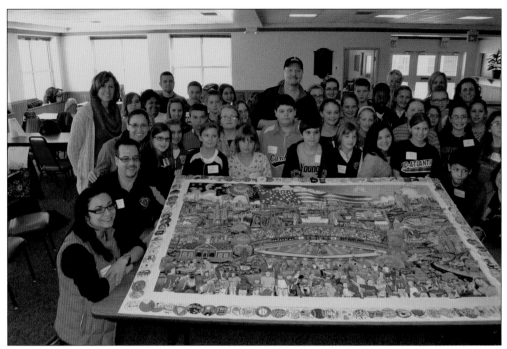

Nationally celebrated 3-D pop artist Charles Fazzino worked with fifth graders from throughout Lycoming and Sullivan Counties on a project commemorating the 75th anniversary of Little League's founding. The First Community Partnership of Pennsylvania initiated the project, which also involved high school art students and art teachers. Fazzino has created similar art for 15 Super Bowls and nine MLB All-Star Games, among other sporting and cultural events.

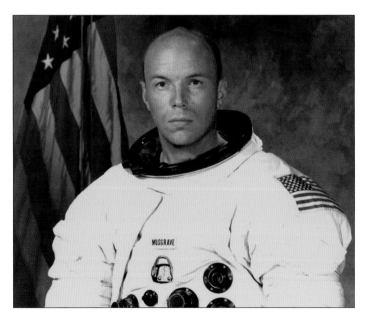

A spacesuit used for NASA training is on loan to the museum from the space administration. Astronaut Dr. Story Musgrave, who played Little League in Stockbridge, Massachusetts, in the 1940s, wore the suit. Already an explorer by the time he was three, Musgrave, who now lives in Florida, continues to learn. He holds seven graduate degrees and was a part-time trauma surgeon. (Courtesy of Dr. Story Musgrave.)

Five

LITTLE LEAGUE®
HALL OF EXCELLENCE

The Hall of Excellence is based on character, courage, and loyalty—the three premises of the Little League motto. Although members of the Hall of Excellence come from all walks of life, each has good character and has gone on to do great things in life since playing in a chartered Little League.

Being a role model does not necessarily mean being famous like Pres. George W. Bush, actor Kevin Costner, astronaut Dr. Story Musgrave, or singer Bruce Springsteen. Instead, in adulthood, inductees must have set an example for children by their actions (Medal of Honor recipient Specialist Ross McGinnis, Principal of the Year Michael Pladus, or firefighter Michael Cammarata).

Submissions for the Hall of Excellence may be made by providing the name, contact information, name of the local league, location, years played, and a detailed biography to Lance Van Auken, executive director of the museum, at lvanauken@LittleLeague.org.

Firefighter Michael Cammarata is among the honorees. Cammarata played for the Staten Island, New York, team at the 1991 Little League Baseball World Series. Wearing the No. 11 jersey, Cammarata played right field. Advancing to the Little League Baseball World Series was a big deal for the whole Cammarata family.

"I was very proud of him. It was one of the first times I felt that way about him," his older brother Joe said, explaining how Little League Baseball impacted his and Michael's lives. "It gave important life experiences: camaraderie and teamwork. I saw that partnership loyalty transferred when he went into the New York City Fire Department. Courage, loyalty and character are ultimately what led him to be the person he was."

Astronaut Dr. Story Musgrave said playing Little League in Massachusetts was a rare happy time in his early years. It was so positive that his children played too. A veteran of six space flights, Musgrave has flown more than 17,000 hours in more than 160 types of aircraft, including the space shuttle and International Space Station. He was instrumental in repairing the Hubble Space Telescope and has spent nearly 1,290 hours in space.

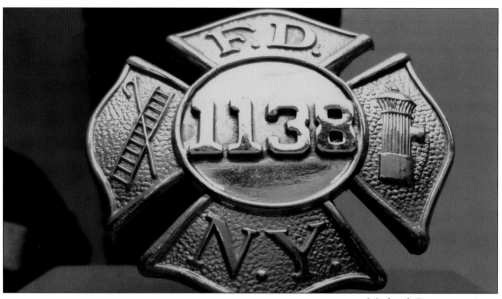

If Anything Ever Happens
To Me........

1. Take Care Of Jenna
2. Dont Mourn As This Is The Career I
Choose
3. Make My Spirit Live On
4. Remember I love You All And Will
Be Waiting For You Upstairs

Michael C
1138

Michael Cammarata's fireman's badge, a photograph of him playing right field at Lamade Stadium in 1991, and a copy of a letter he wrote to his family are in the museum. The No. 11 seen on the outfield fences at Lamade and Volunteer Stadiums reminds visitors of one of the thousands of Americans who lost their lives on September 11, 2001. Cammarata worked at Manhattan's Ladder Company 11 firehouse, and he left a message on his father's voice mail at 8:45 a.m.: "I am going to the World Trade Center, a plane just hit it. Just tell everyone I am all right." He never returned home. His family found this letter in a drawer in his nightstand. Cammarata was inducted in 2002.

Placing his life on the line was Ross McGinnis, who posthumously received the Medal of Honor for sacrificing himself to save four US Army soldiers from an exploding grenade in 2006 while serving in Iraq. His mother, Romayne, of Knox, Pennsylvania, said Little League Baseball changed her son's outlook on life and taught her son the values of teamwork, self-worth, and commitment to achieving common goals. He was inducted in 2011. (Courtesy of the McGinnis family.)

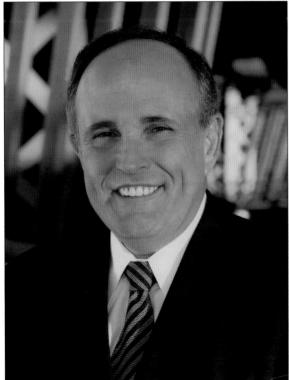

Former New York City mayor Rudolph Giuliani was inducted in 2002 for his compassionate leadership in the aftermath of the deadliest terrorist attack in the United States on September 11, 2001. Giuliani was credited by many for helping the city and the nation stay focused on remembrance and recovery. Giuliani played in the Garden City South Little League on Long Island, New York.

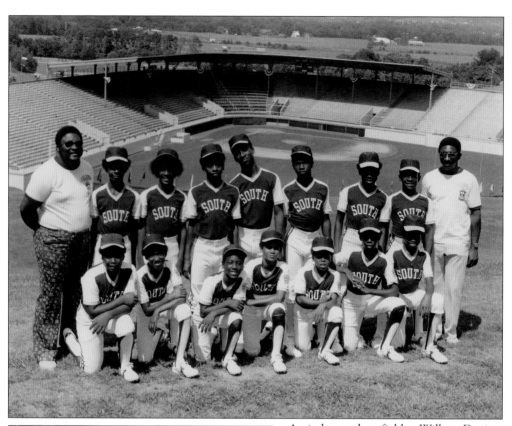

A pitcher and outfielder, Wilbert Davis (second row, third from left) played on a Little League team from Belmont Heights, Florida, in the World Series in 1975. Davis's team advanced to the final game where it was defeated by Lakewood, New Jersey. That year, all non-US teams were banned from advancing beyond regional play because of an overemphasis on tournament play. He was the first known Little Leaguer who died in Desert Storm. He was inducted in 2003. (Both, courtesy of the Wilbert Davis family.)

Pres. George W. Bush was inducted to the Hall of Excellence in 2001, less than a month before the terrorist attacks. He attended the Little League Baseball World Series to accept the award. A member of Central Little League of Midland, Texas, in the 1950s, Bush cites Little League as his favorite childhood memory. He is the first Little Leaguer to become a president of the United States and hosted Tee Ball on the South Lawn, giving Little Leaguers an opportunity to play ball on the grounds of the White House in Washington, DC.

Little League Baseball, Inc.

REGULAR TEAM ROSTER

4-0
RECEIVED

TO: LITTLE LEAGUE BASEBALL, INC.
Williamsport, Pa.

June 4 13 3 4 1955

Submitted herewith is the team roster of the CUBS Team

In the CENTRAL Little League

Address of League MIDLAND TEXAS
(City) (State)

	NAME OF PLAYER	STREET ADDRESS	CITY	DATE OF BIRTH (Month, Day, Year)
1.	JIMMY COTTON	2317 Cuthbert	Midland, Texas	7/9/43
2.	Billy Bonno	2009 Princeton	Midland	1/31/43
3.	Raymond Lynch, Jr.	1500 Harvard	Midland	7/3/43
4.	Ross Dawkins	1402 W. Michigan	Midland	10/24/42
5.	Larry Hambrick	W. Louisiana	Midland	7/25/43
6.	Bob Stuart	2213 Harvard	Midland	10/26/43
7.	Frank Montagna	2204 W. Washington	Midland	1/6/44
8.	Martin Buckley	2212 Harvard	Midland	10/14/43
9.	Alan Henderson	2603 Cuthbert	Midland	3/11/44
10.	Joseph I. O'Neill III	1600 Cuthbert	Midland	6/11/44
11.	Bob Ittner	1502 W. Storey	Midland	8/2/44
12.	George Bush	1412 W. Ohio	Midland	7/6/46
13.	Roy Morton	Pinkies Farm Store	Midland	11/3/45
14.	Mike Beadle	2505 Country Club Drive	Midland	8/27/45
15.	Bob Stanley	2505 Holloway	Midland	10/14/45

	NAME OF MANAGER AND COACH	ADDRESS		
1.	Curtis R. Inman	P. O. Box 757	Midland, Texas	
2.	Frank Ittner	1502 W. Storey	Midland, Texas	

Signed *Harry Stussell*
(Player Agent)

Mail one (1) copy to Little League Baseball, Inc., Williamsport, Pa., within fourteen (14) days after the first regular scheduled game. Keep one (1) copy for your files.

Changes in this roster must be mailed within five (5) days after change. No special form is required. A postal card will suffice. Give name, complete address and date of birth of substitute and name of boy he replaces, and name and address of league.

Form LL55-9

PLEASE TYPEWRITE IF POSSIBLE

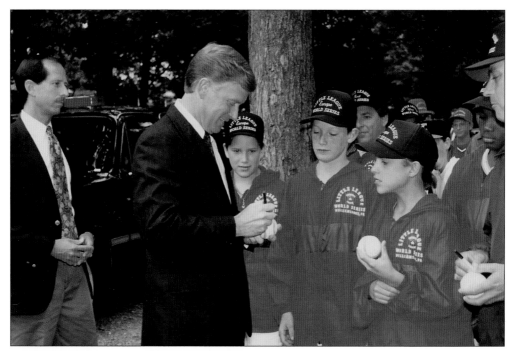

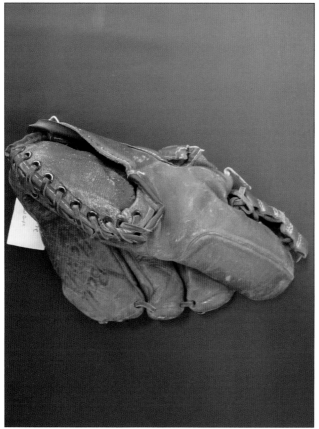

Vice Pres. Dan Quayle, who served with Pres. George H.W. Bush from 1989 to 1993, was inducted in the Hall of Excellence in 1990. Quayle, a member of the Hoosier Little League, Huntington, Indiana, was the first Little League graduate to be elected vice president. He is shown above at the series in 1992. At left is his glove.

US vice president Joseph Biden, who was part of the Green Ridge Little League in Scranton, Pennsylvania, was inducted in 2009. Biden is shown accepting his award in Lamade Stadium prior to the championship game. He is known for his devotion to his family and his work during six terms as senator on justice issues, particularly the 1994 Crime Bill and the Violence Against Women Act.

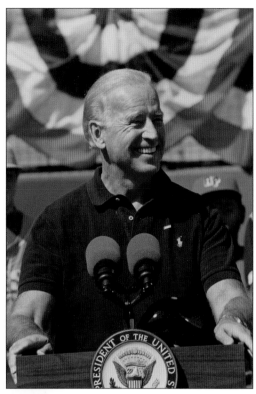

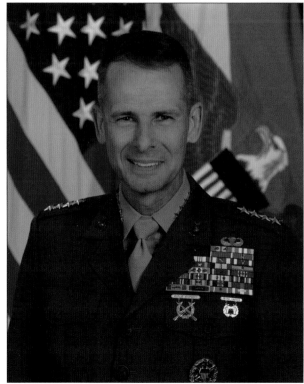

Gen. Peter Pace, a Marine and former chairman of the Joint Chiefs of Staff under Pres. George W. Bush, was recognized in 2003 for his courage, character, and loyalty while serving his country. Pace played baseball for Southern Little League in his hometown of Teaneck, New Jersey, in the 1950s.

73

New Jersey governor Chris Christie, inducted in 2013, was a catcher for a Little League team in Livingston, New Jersey. His father was the team's coach. Christie, elected governor in 2010, earned praise for his leadership before, during, and after Hurricane Sandy hit New Jersey in October 2012. Teammate Harlan Coben, an accomplished *New York Times* best-selling author who played the outfield and first base, was inducted the same year. Pictured below are Chris Christie (in red) and Harlan Coben standing next to him. (Above, courtesy of Gov. Chris Christie.)

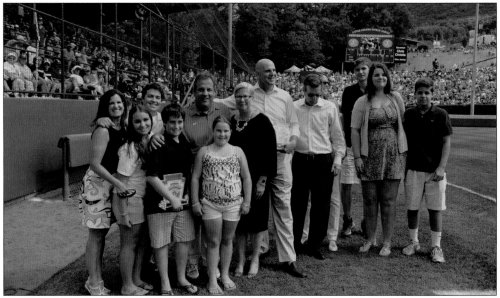

Hall of Fame pitcher Tom Seaver is pictured in 1988 signing autographs when he was inducted as the charter member of the Hall of Excellence. Seaver played from 1954 to 1957 on a Spartan Little League team from Fresno, California.

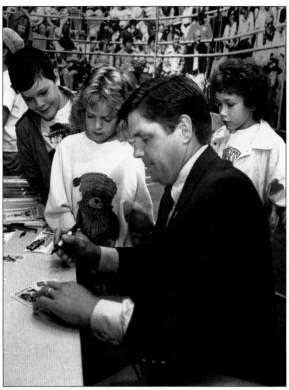

Baseball Hall of Fame pitcher Jim Palmer was inducted in 1994. A graduate of the Beverly Hills, California, Little League, Palmer was the first pitcher to post a MLB World Series victory in three decades. Palmer was a commentator for ABC Sports during the Little League Baseball World Series.

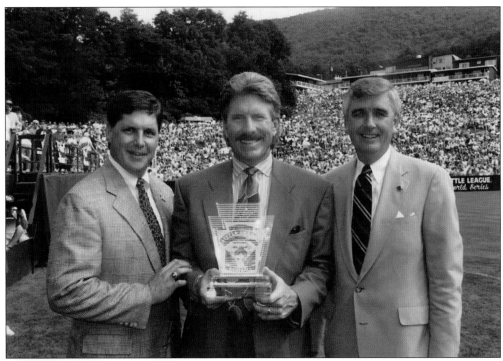

Major-leaguer Mike Schmidt was inducted in 1991. Schmidt retired in 1989 having hit 548 home runs, driving in 1,595 runs, and collecting 1,015 extra-base hits. He is pictured with Tom Seaver, left, and Bob Kloss, right, chairman of the museum.

Mike Schmidt is a graduate of the North Riverdale Little League in Dayton, Ohio. His green cap bearing the letters "LL" is on display. During his stellar 18-season career with the Philadelphia Phillies, he earned three National League Most Valuable Player Awards and was awarded the Gold Glove 10 times.

Major League Baseball's all-time strike-out record holder is a graduate of the Alvin Little League in Alvin, Texas. Nolan Ryan's children played in the Alvin Little League too. Ryan ranks among the all-time leaders in games started, innings pitched, shutouts, and earned run average, and he was the 18th pitcher to win 300 games. He was named to the Hall of Excellence in 1991. (Courtesy of Nolan Ryan.)

Inducted in 1995, major-leaguer Dale Murphy was a graduate of the Tualatin Little League in Portland, Oregon. Murphy won five consecutive Gold Glove awards. In 1983, he became the youngest of only four players to win back-to-back Most Valuable Player Awards. He was presented Major League Baseball's Lou Gehrig Memorial Award in 1985 as the player who best exemplifies the image and character of a Hall of Famer.

Mike Mussina, inducted into the Hall of Excellence in 2014, was honored for his volunteer commitment. The major-leaguer was elected to the Little League International Board of Directors in 2001. He wore the glove pictured below when he was a member of the Montoursville (Pennsylvania) Little League and drew the baseball card—complete with his statistics. Mussina's Johnny Z's jersey is in the Third Inning (gallery). He is featured in the catcher's interactive in the Fourth Inning (gallery).

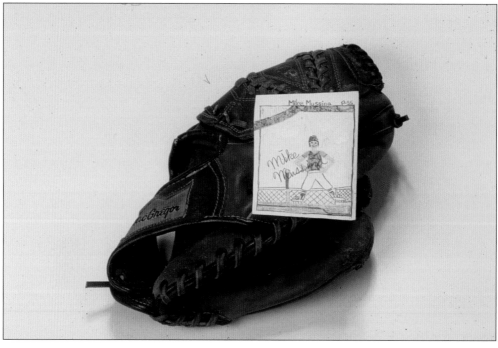

Major-leaguer Cal Ripken Jr. (second row, fourth from left) had his start in the West Asheville Little League in Asheville, North Carolina. A pitcher and a shortstop in 1973, Ripken's team played in the Little League Baseball Southern Regional Tournament in St. Petersburg, Florida. The National Baseball Hall of Famer eventually surpassed Lou Gehrig's consecutive-games-played record. He was inducted in 1996. (Courtesy of the Ripken family.)

Leonard S. Coleman, president of the MLB National League, was inducted in 1996. He was named the 14th president of the league in 1994, following more than two decades of exemplary professional and community service. His community involvement includes work with the Little League Foundation, the Martin Luther King Jr. Center for Nonviolent Social Change, and the Children's Defense Fund, among others. Coleman played Little League in Montclair, New Jersey. (Courtesy of Leonard Coleman.)

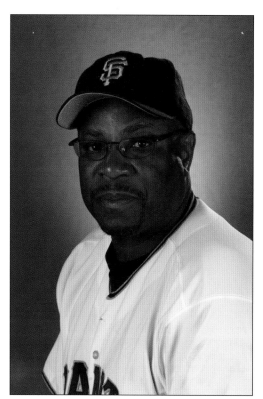

A Little Leaguer from Riverside, California, Dusty Baker played Major League Baseball for 19 years. As a Los Angeles Dodger, he won a World Series ring in 1981. A baseball analyst for ESPN, Baker has managed the San Francisco Giants, the Cincinnati Reds, and the Chicago Cubs. Baker was inducted in 2007. (Courtesy of the San Francisco Giants.)

In 1952, Don Beaver and his teammates proudly represented the Southern Region during the series for the Mooresville, North Carolina, Little League. Now, as an owner of several minor-league baseball teams around the country and a minority owner of the Pittsburgh Pirates, this highly respected businessman still holds pitching in the World Series as his most cherished moment throughout all of his sporting activities. Beaver was inducted in 1999. (Courtesy of Don Beaver.)

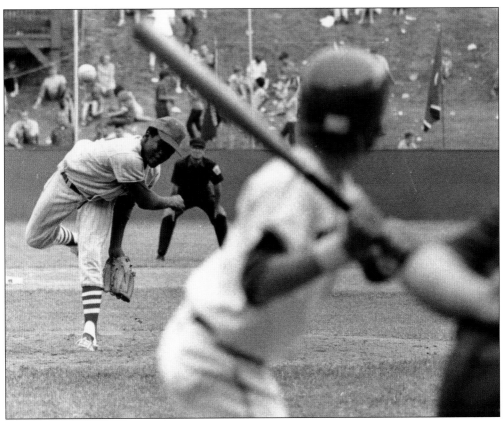

Lloyd McClendon, pitching for Anderson Little League of Gary, Indiana, in the 1971 series, became known as "Legendary Lloyd" for his performance over three series games, dominating as a pitcher and as a hitter, with five home runs, 10 runs batted in, and five intentional walks in 10 plate appearances. McClendon, inducted in 2006, become a role model for children during his career as a major-league player, manager, and coach.

Jose Maiz Garcia, a civil engineer, businessman, and owner of the Monterrey Sultans of the Mexican League, played in 1957 for Monterrey's Industrial Little League. Learning "discipline, teamwork, obedience, and how to win and lose" from Little League, Garcia has given back to the program and to his community. He heads one of the largest construction firms in Mexico. In 2005, he was the first non-US person to be inducted in the Hall of Excellence.

Tony Dungy, first as a player in the National Football League, and then as a head coach, brings lessons learned on the Little League field at Southeast Little League of Jackson, Michigan, to his team: sportsmanship, teamwork, and a dedication to excellence. A representative for the National Fellowship of Christian Athletes, Dungy helps other athletes become positive role models worthy of emulation. He was inducted in 1998. (Courtesy of the Tampa Bay Buccaneers.)

"Friends, fun, and teamwork" are the three adjectives that spring to Brian Sipe's mind when he remembers his Little League days. A member of the 1961 Little League Baseball World Series championship team, Northern Little League, El Cajon, California, Sipe went on to a highly successful career as one of the best quarterbacks in the National Football League. He was inducted in 1999.

A football signed by Ozzie Newsome, who was inducted in 2008, is on display at the World of Little League Museum. Newsome is the first African American to hold a position as general manager of a National Football League (NFL) team, the Baltimore Ravens. He had a 13-year Hall of Fame NFL career. As a youngster, he played Little League in the Muscle Shoals Little League in Alabama.

Hale Irwin attended the University of Colorado where he excelled at football. He is considered one of the most successful members of the Professional Golfers' Association. A graduate of the Baxter Springs, Kansas, Little League, he has won three US Open championships and was a member of the US World Cup Team twice and a member of the US Ryder Cup Team five times. Irwin was inducted in 1993. (Courtesy of Hale Irwin.)

Kyle Petty, an eight-time winner on the National Association for Stock Car Auto Racing (NASCAR) circuit, was inducted in 2010. Petty played in the Southern Little League in Randleman, North Carolina. Now a NASCAR television analyst, Petty has hosted the Kyle Petty Charity Ride Across America, a motorcycle trip benefitting Victory Junction, a camp for children with medical issues. He is shown accepting his award from Steve Keener, Little League president and chief executive officer.

Elmont Little League, Queens, New York, is where Dr. Vincent Fortanasce, left, played baseball. Inducted in 1994, he is a psychiatrist and neurologist as well as a clinical professor at the University of Southern California School of Medicine. He twice was named Outstanding Teacher of the Year. Also a member of the 1964 US Olympic Weightlifting team, Fortanasce is pictured with Dr. Creighton Hale, former president and chief executive officer.

Dan O'Brien, inducted in 1997, is a world record holder and 1996 Olympic gold medalist in the decathlon, giving him the unofficial title of world's best athlete. He played at South Suburban Little League in Klamath Falls, Oregon, and O'Brien won the 1993 world championship. He works with organizations such as Wendy's Foundation, United Way, Ronald McDonald House, and the Orphan Foundation of America. (Courtesy of Dan O'Brien.)

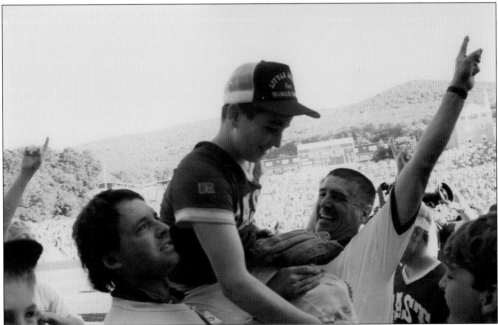

Chris Drury pitched for the Trumbull, Connecticut, team that won the Little League Baseball World Series in 1989. It was the first time a league from the United States won against Chinese Taipei since 1983. Drury was captain of the New York Rangers of the National Hockey League. He also played on the US Olympic hockey team in 2001 and 2008. He was inducted in 2009.

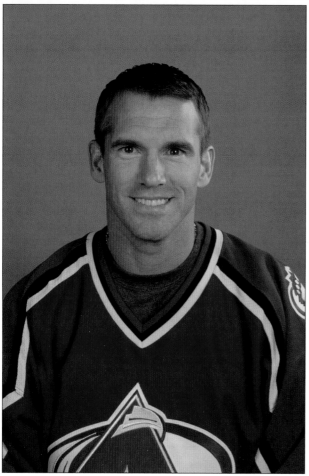

Ice hockey player Pierre Turgeon is the first Canadian-born inductee in the Hall of Excellence. He played Little League Baseball in Rouyn, Quebec, Canada, and was a member of the Canadian National Championship team that played in the 1982 Little League Baseball World Series. He was a standout pitcher and shortstop. Turgeon pitched a no-hitter with 10 strikeouts and no walks in Canada's 3-0 victory over Torrejon Air Force Base of Madrid, Spain. Inducted in 2007, he was the 34th player in National Hockey League history to score 500 goals, retiring after 19 seasons. (Left, courtesy of Pierre Turgeon.)

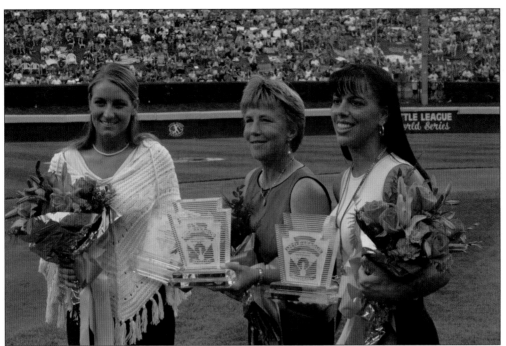

Three women athletes were inducted in 2004. Krissy Wendell, left, a Little Leaguer from Minnesota, became one of the best women's ice hockey players in America; Cathy Gerring, center, a professional golfer, played Little League in Fort Wayne, Indiana; and Nancy dosReis, right, a detective in the Providence, Rhode Island, police department, played in the 1979 Little League Softball World Series in Waco, Texas. It was the first time women were named to the Hall of Excellence. Wendell, at right, played in Williamsport in 1994 for Brooklyn Park American Little League and was the first girl catcher in the Little League Baseball World Series.

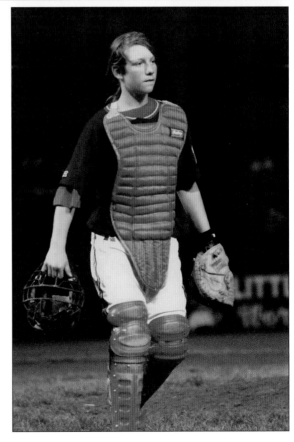

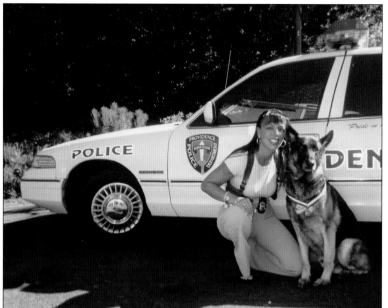

Providence, Rhode Island, police detective Nancy dosReis, who earned a master's degree from Roger Williams University, made national headlines in 1996 when she and her K-9 partner were credited with the arrest of a convicted murderer who had escaped from a maximum-security prison.

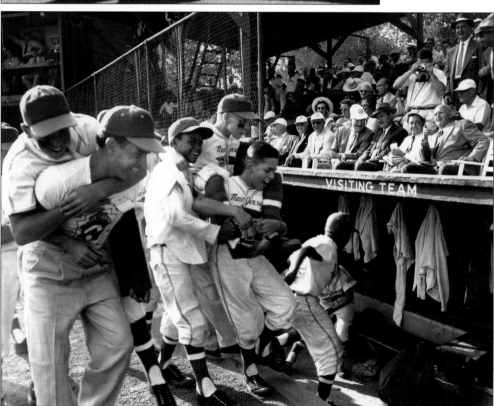

George H. "Billy" Hunter played in the Little League Baseball World Series and went on to become executive director of the National Basketball Players Association. In 1955, Hunter led his Delaware Township, New Jersey, Little League team to the finals of the series. "It was phenomenal, a high point in my life," said Hunter, who was inducted in the Hall of Excellence in 2000.

Kareem Abdul-Jabbar, the all-time leading scorer in National Basketball Association (NBA) history and NBA Hall of Famer, played in the Inwood Little League in New York City where he was awarded his team's sportsmanship award. Abdul-Jabbar has been named NBA Most Valuable player six times. He is second in NBA history for most games played and holds the NBA record for career blocked shots. He was inducted in 1992. (Courtesy of Kareem Abdul-Jabbar.)

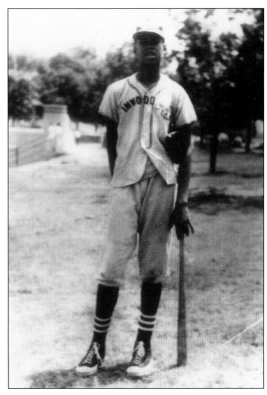

Bill Bradley, left, a graduate of the Crystal City, Missouri, Little League is pictured with Bob Kloss, chairman of the museum. Inducted in 1989, Bradley has demonstrated an exceptional balance of superior academic and sports accomplishments. An All-American basketball player and Olympian, he played professional basketball with the New York Knicks and was a US senator for New Jersey.

Dr. Robert Stratta considers pitching in the 1967 Little League Baseball World Series championship game for North Roseland Little League of Chicago a high point of his life. He has been a transplant surgeon and professor of surgery at the University of Tennessee at Memphis since 1997. He also led the clinical pancreas transplant team at the University of Nebraska at Omaha for seven years. He was inducted in 2000.

Like many children, Robert Sloan played Little League just for "something to do." But Little League became one of the forces that drove him to success. The graduate of Western Little League in Abilene became president of Baylor University in Waco, Texas. Inducted in 1996, Sloan, a Little League coach from 1984 to 1990, has authored two books and more than 50 articles. (Courtesy of Robert Sloan.)

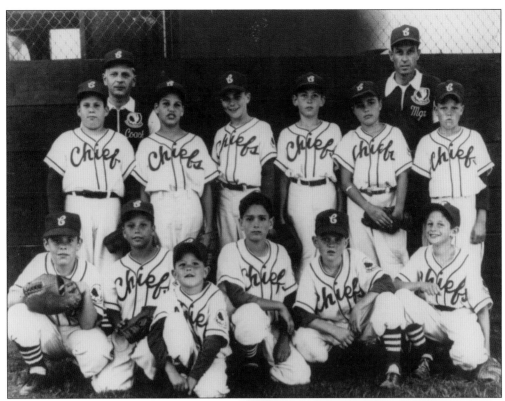

Tom Selleck (second row, third from left) was an all-star pitcher with the Pioneer Little League of Sherman Oaks, California. This multitalented actor has earned both an Emmy Award and Golden Globe Award. His highly successful series *Magnum, P.I.* enjoyed eight seasons as one of network television's most popular programs. Selleck has starred in several hit movies and the television series *Blue Bloods*. He was inducted in 1991. (Courtesy of Tom Selleck.)

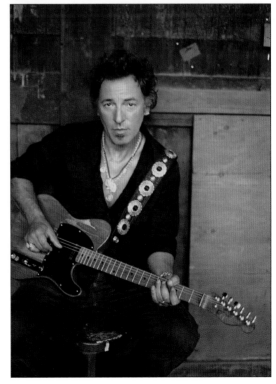

Bruce Springsteen, named in 1997, once stated, "Little League has a big, positive impact in my life." He often talks about his Little League days in Freehold, New Jersey, during concerts. His impact on other people's lives has been big and positive as well. He frequently donates income from T-shirts and other merchandise sold at his concerts to selected soup kitchens, veterans' groups, and homeless shelters. (Courtesy of Bruce Springsteen.)

The Academy Award–winning director and actor Kevin Costner, right, knows the entire team is important to the success of any project. It is one of the lessons he learned as a star pitcher in the Saticoy Little League of Ventura, California. He said, "You learn how you have to depend on teammates, because even on no-hitters there's someone behind you making a play." Shown with major-leaguer Orel Hershisher, Costner was inducted in 2000.

A successful columnist and author, as well as one of college basketball's top analysts and ambassadors, Dick Vitale received his award in 2012. An ESPN personality, Vitale is a member of 11 sports Halls of Fame, including the Naismith Memorial Basketball Hall of Fame. He played Little League in Garfield, New Jersey.

George Will, a graduate of the Champaign, Illinois, Little League, is a nationally syndicated columnist, political analyst, and best-selling author. He earned the Pulitzer Prize for commentary in 1977. His New York Times Best Seller List book *Men at Work* is considered the best "nuts and bolts" book about baseball. It was published in 1990 and re-released in 2010. His induction was in 1992. (Courtesy of George Will.)

Inducted in 1998, Dave Barry fondly recalls when "Little League dominated his life in late spring and early summer." Now a best-selling author, syndicated columnist, and Pulitzer Prize winner, he remembers his Little League career in Armonk, New York, as a time when he "learned a lot." Barry's community involvement includes working with Big Brothers/ Big Sisters. (Courtesy of Dave Barry.)

Shenandoah North, Pennsylvania, Little Leaguer Michael Pladus was named 1999 National High School Principal of the Year. It was his dedication to his students and his drive to help them succeed that led to his Principal of the Year award and his inclusion in the Hall of Excellence in 1999. (Courtesy of Michael Pladus.)

Fifty years ago, Ron Ricks (second row, right) played in the Little League Baseball World Series as a member of the 1962 South Region champions from Val Verde County Little League of Del Rio, Texas. Inducted in 2012, Ricks is executive vice president and chief legal and regulatory officer of Southwest Airlines. He started with the company in 1981, when it was a small regional passenger carrier. With its subsidiary, AirTran Airways, Southwest has 45,000 employees, the most passengers of any airline in the United States, and has one of the world's largest fleets.

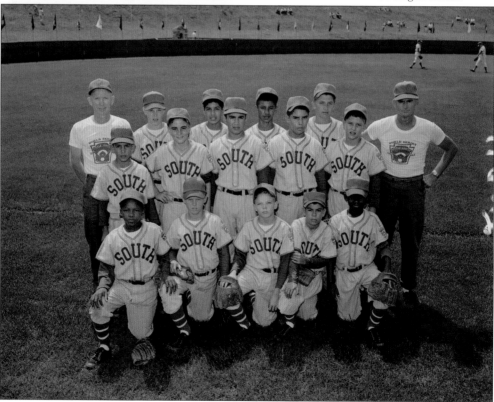

Dr. Story Musgrave is a NASA astronaut who was instrumental in the first repair of the Hubble Space Telescope in 1993, pictured. The mission for the space shuttle was more complex than most because astronauts were in flight for 10 days. Named in 1994 to the Hall of Excellence, he played Little League in Massachusetts. (Courtesy of Dr. Story Musgrave.)

DISCOVER THOUSANDS OF LOCAL HISTORY BOOKS
FEATURING MILLIONS OF VINTAGE IMAGES

Arcadia Publishing, the leading local history publisher in the United States, is committed to making history accessible and meaningful through publishing books that celebrate and preserve the heritage of America's people and places.

Find more books like this at
www.arcadiapublishing.com

Search for your hometown history, your old stomping grounds, and even your favorite sports team.